Masterpieces of

Reynolds

(1909)

ISBN-13 : 978-1512322552
ISBN-10 : 1512322555

Copyright©2012-2014 Iacob Adrian
All Rights Reserved.

Notice

This documentary study use historic, archived documents. Because of this, some pages may look blurry or low quality. Still are included in this book because they have high value from critical, documentary, historical, informative and journalistic point of view .

Dtp and visual art

Iacob Adrian

THE
MASTERPIECES
OF
REYNOLDS
(1723-1792)

Sixty reproductions of photographs from the original paintings by F. Hanfstaengl, affording examples of the different characteristics of the Artist's work

Author statement

This is a series of art books.

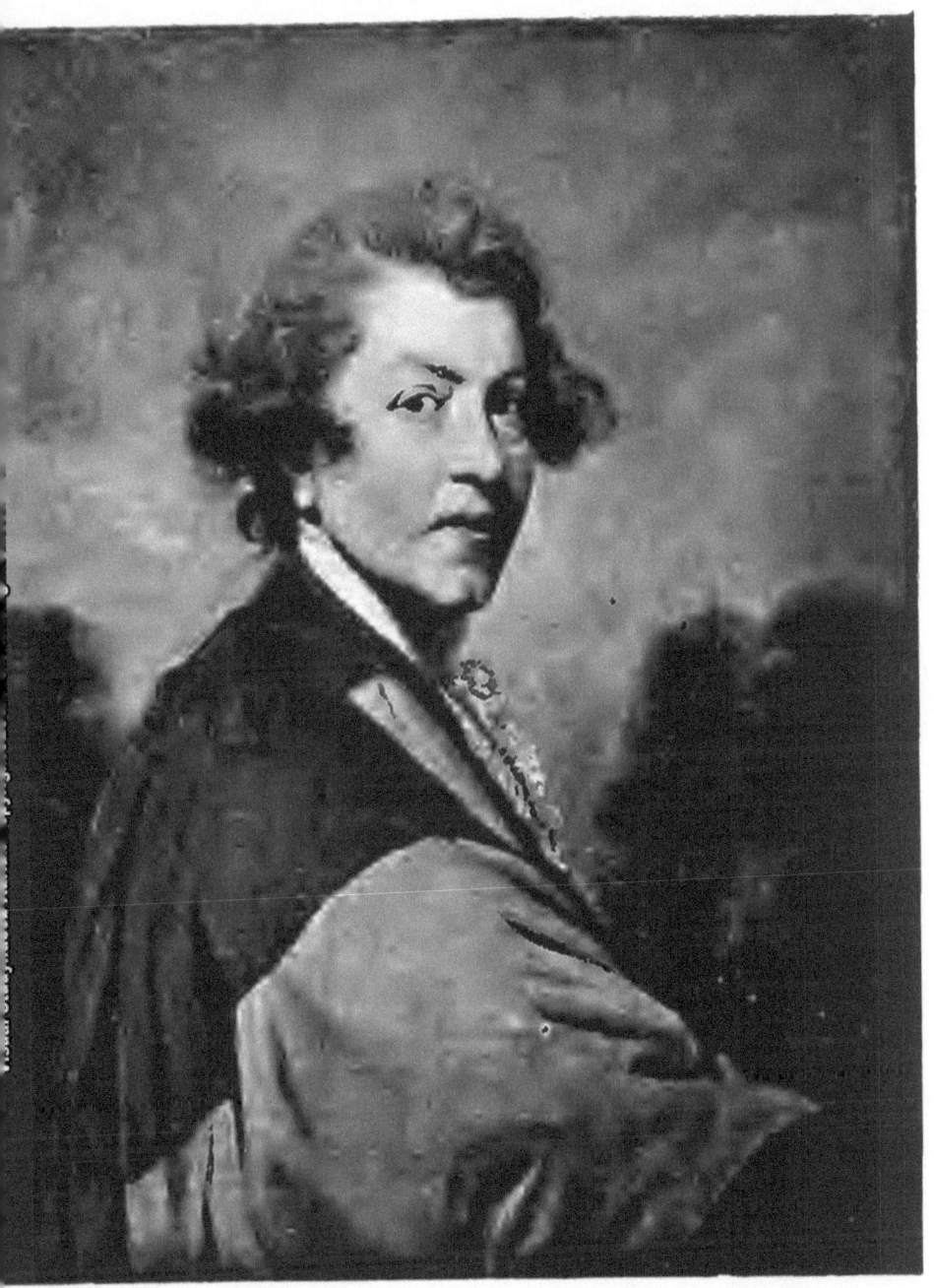

PORTRAIT OF HIMSELF
(*Earl Spencer, Althorp*)

PORTRAIT DE L'ARTISTE
(*Comte Spencer, Althorp*)

SELBSTBILDNIS
(*Althorp, Graf Spencer*)
F. Hanfstaengl, Photo.

This little Book conveys the greetings of

..

to

..

PORTRAIT OF HIMSELF
(National Gallery, London)

PORTRAIT DE L'ARTISTE
(Galerie nationale, Londres)

SELBSTBILDNIS
(London, Nationalgalerie)

F. Hanfstaengl, Photo.

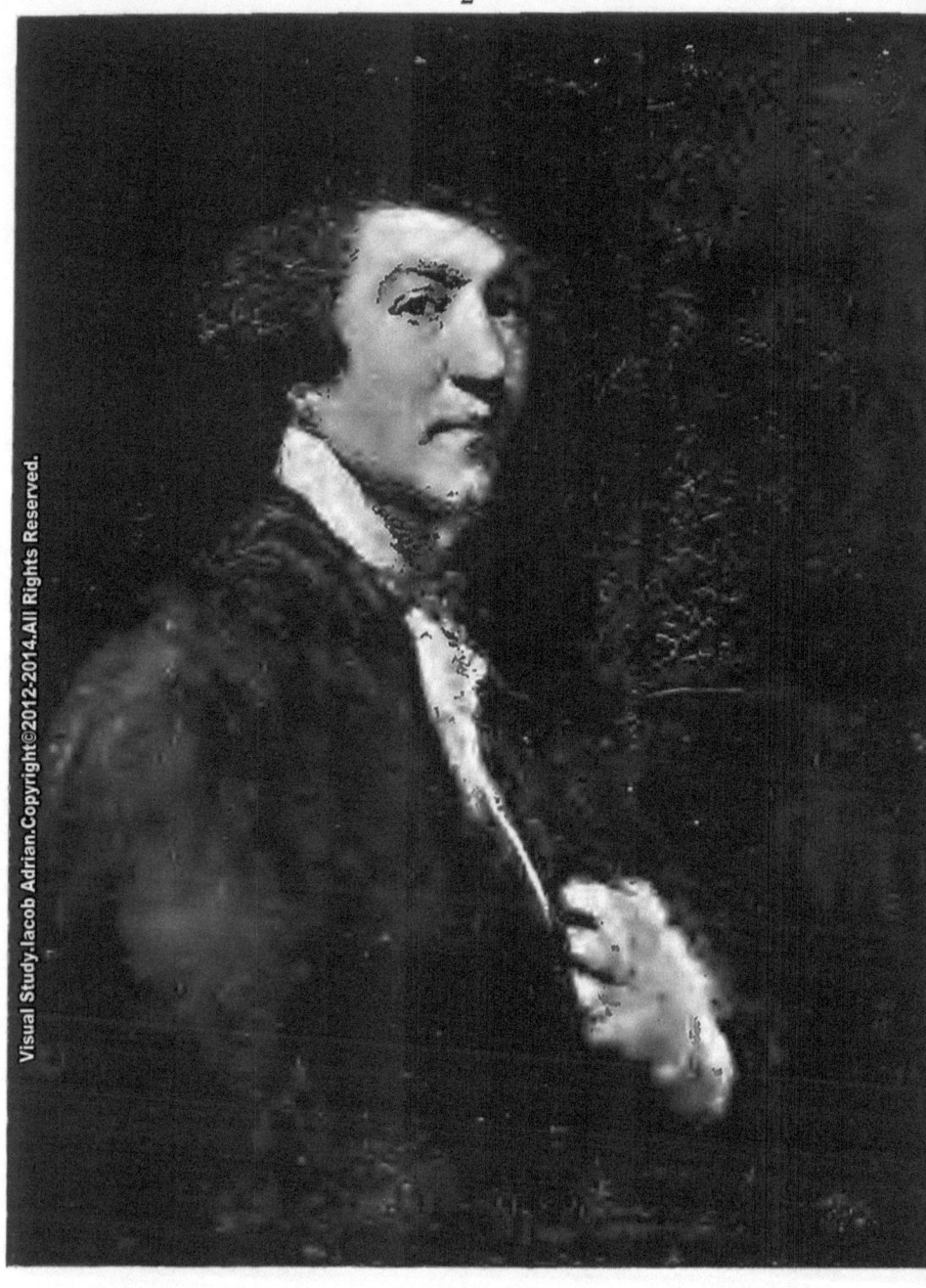

PORTRAIT OF HIMSELF
(National Gallery, London)

PORTRAIT DE L'ARTISTE
(Galerie nationale, Londres)

SELBSTBILDNIS
(London, Nationalgalerie)

F. Hanfstaengl, Photo.

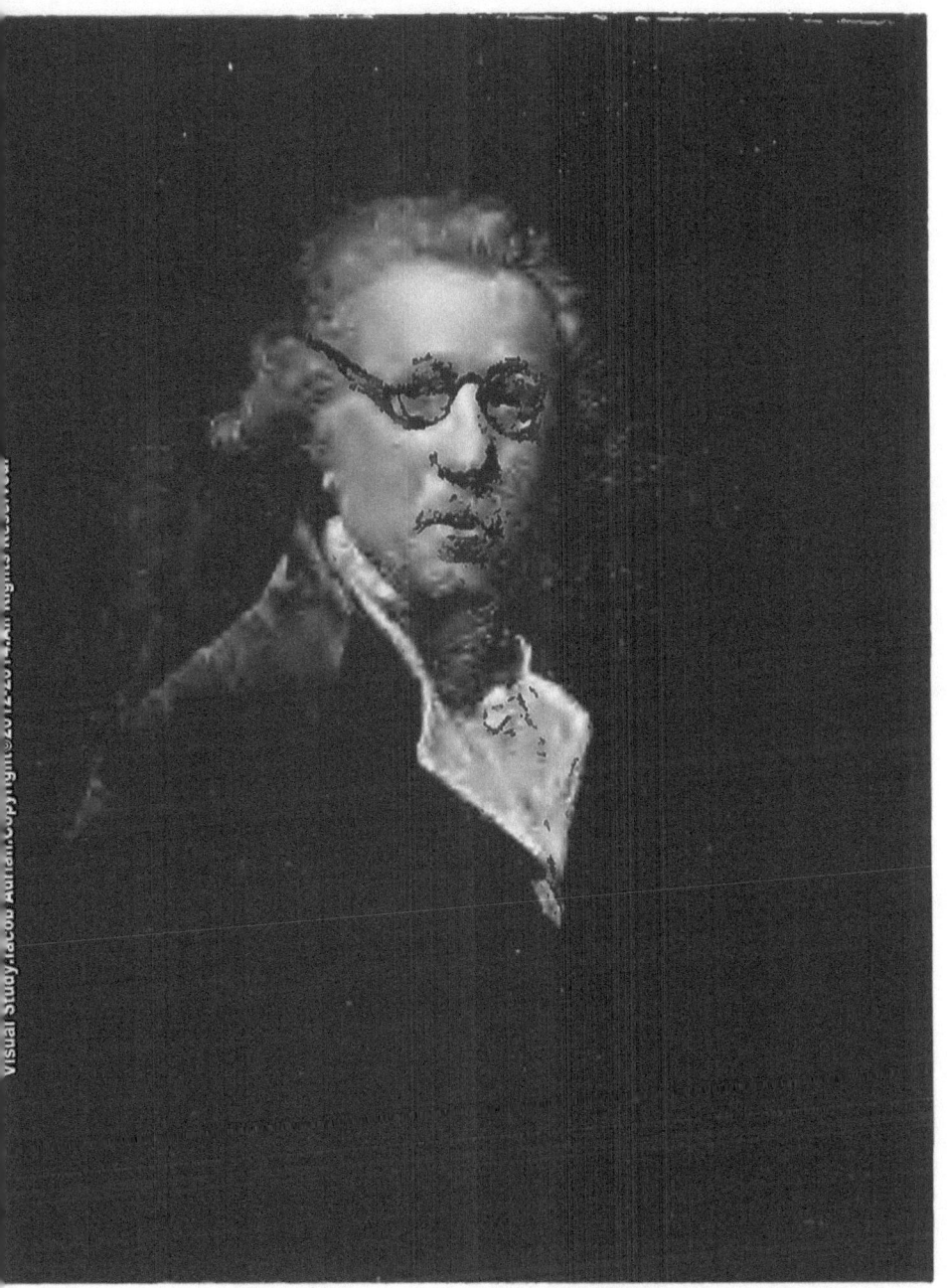

PORTRAIT OF HIMSELF PORTRAIT DE L'ARTISTE
(Buckingham Palace, London) (Palais Buckingham, Londres)
SELBSTBILDNIS
(London, Buckinghampalast)
F. Hanfstaengl, Photo.

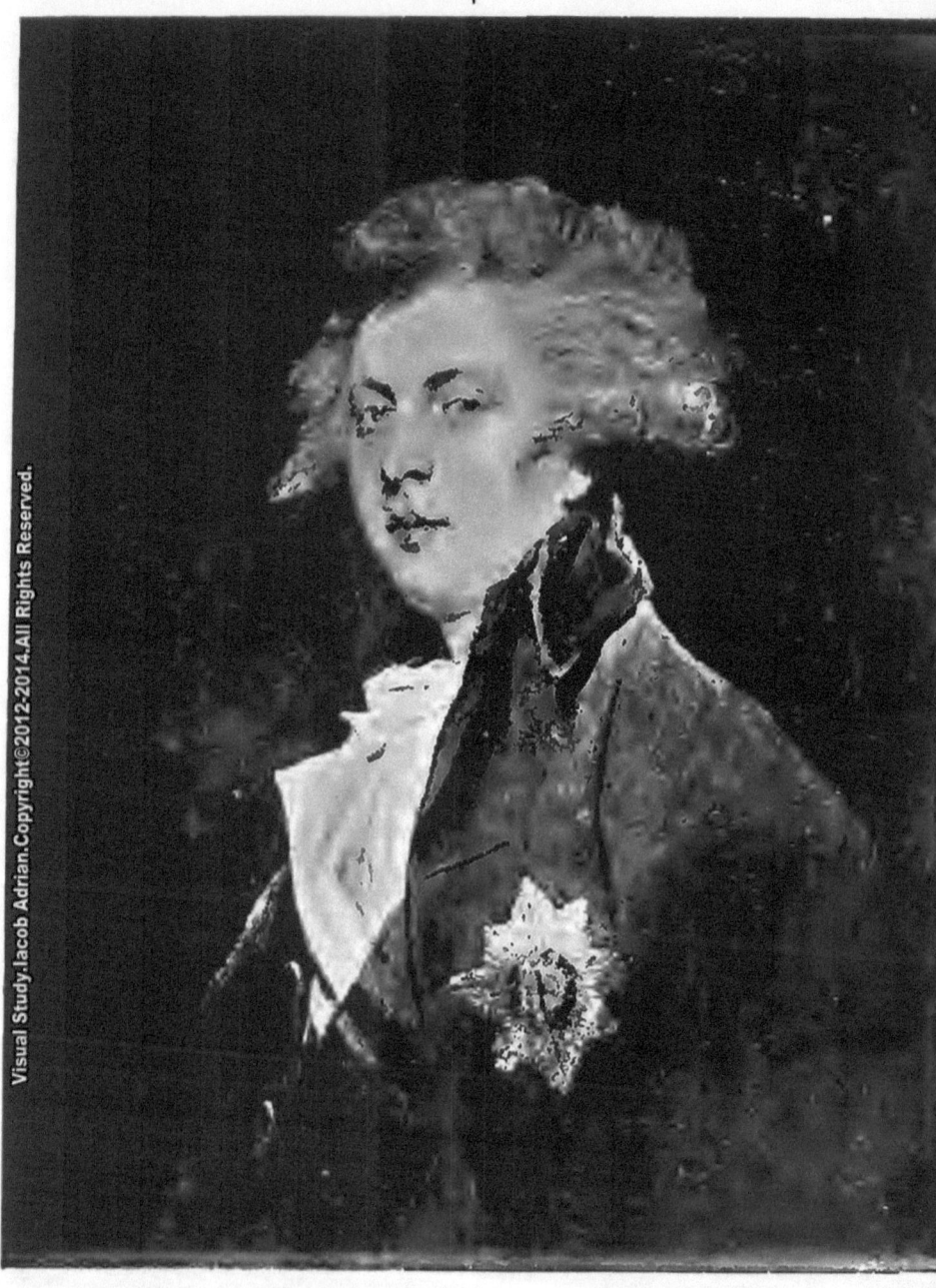

GEORGE IV. AS PRINCE F WALES LE PRINCE DE GALLES,
(National Gallery, London) PLUS TARD GEORGE IV.
(Galerie nationale, London)
GEORG IV. ALS PRINZ VON WALES
(London, Nationalgalerie)
F. Hanfstaengl, Photo.

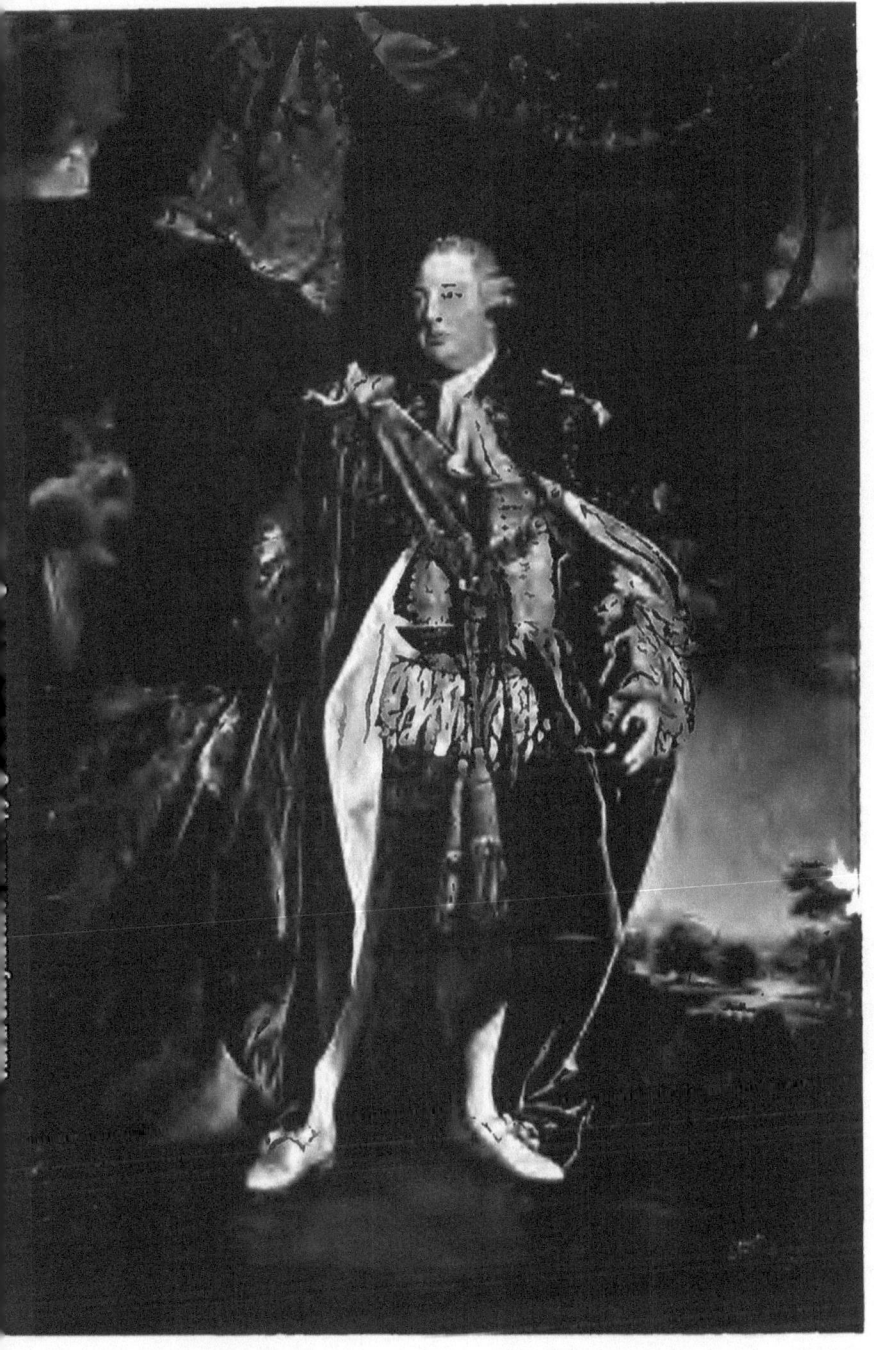

WILLIAM AUGUSTUS, WILLIAM AUGUSTUS,
DUKE OF CUMBERLAND DUC DE CUMBERLAND
(Duke of Devonshire, Chatsworth) (Duc de Devonshire, Chatsworth)
WILLIAM AUGUSTUS, HERZOG VON CUMBERLAND
(Chatsworth, Herzog von Devonshire) F. Hanfstaengl, Photo.

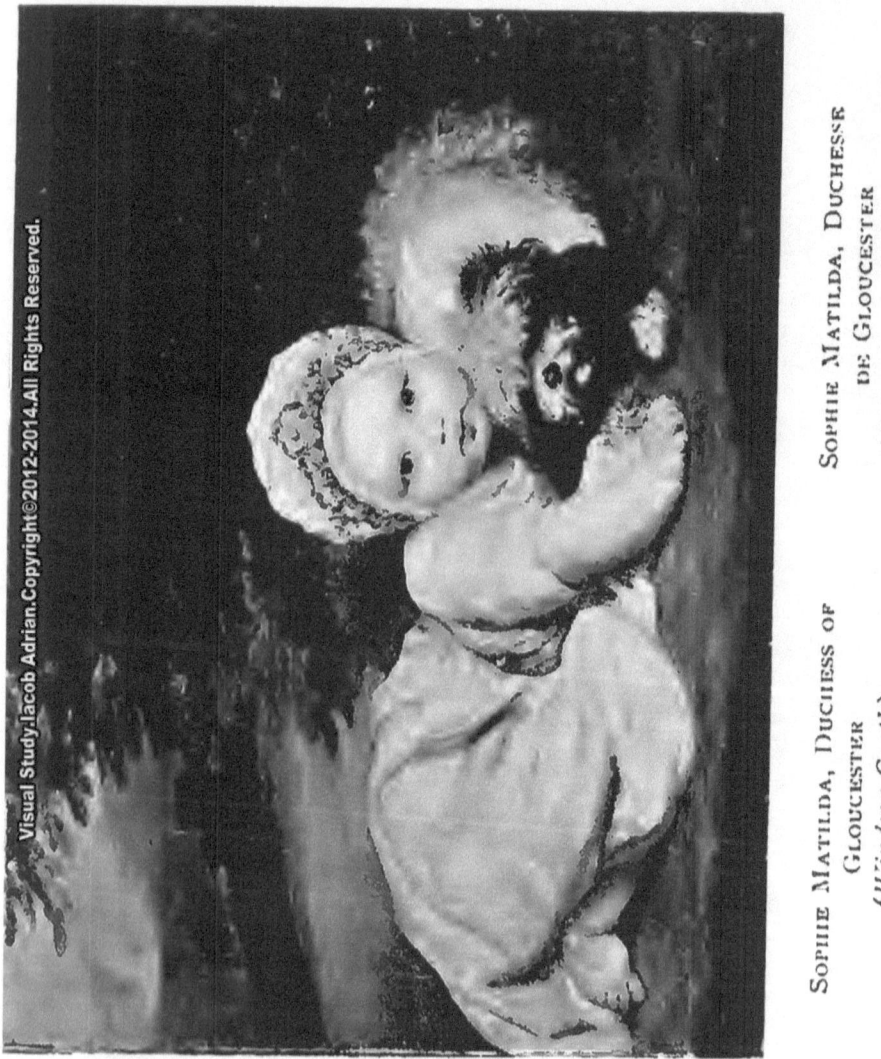

Sophie Matilda, Duchess of Gloucester
(*Windsor Castle*)
Sophie Matilda, Duchesse de Gloucester
(*Galerie royale, Windsor*)
Herzogin Sophie Matilda von Gloucester als Kind

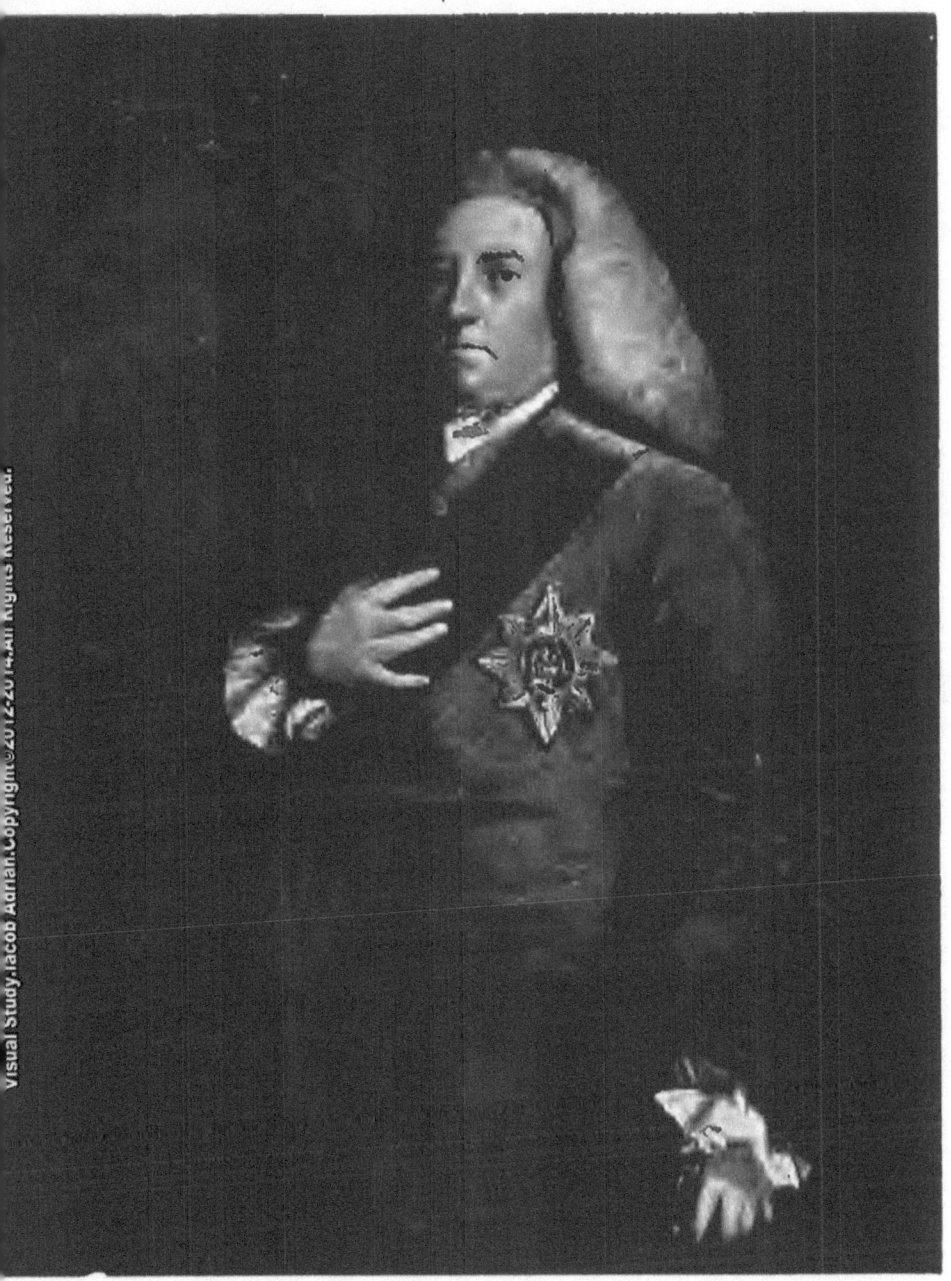

WILLIAM, WILLIAM,
THIRD DUKE OF DEVONSHIRE TROISIÈME DUC DE DEVONSHIRE
(Duke of Devonshire, Chatsworth) (Duc de Devonshire, Chatsworth)
WILLIAM, DRITTER HERZOG VON DEVONSHIRE
(Chatsworth, Herzog von Devonshire)
F. Hanfstaengl, Photo.

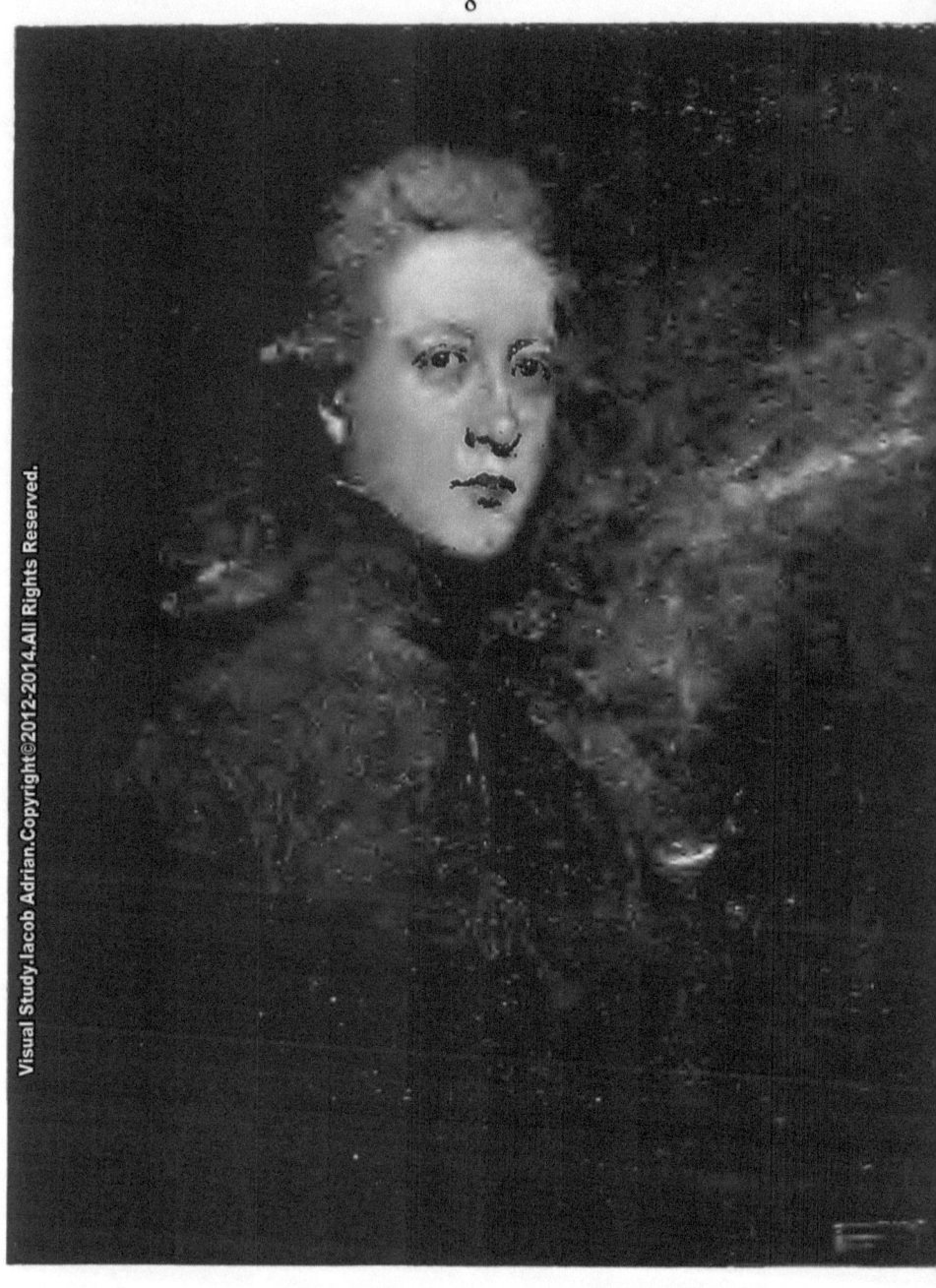

WILLIAM, FIFTH DUKE OF DEVONSHIRE
(*Earl Spencer, Althorp*)

WILLIAM, CINQUIÈME DUC DE DEVONSHIRE
(*Comte Spencer, Althorp*)

WILLIAM, FÜNFTER HERZOG VON DEVONSHIRE
(*Althorp, Graf Spencer*)

F. Hanfstaengl, Photo.

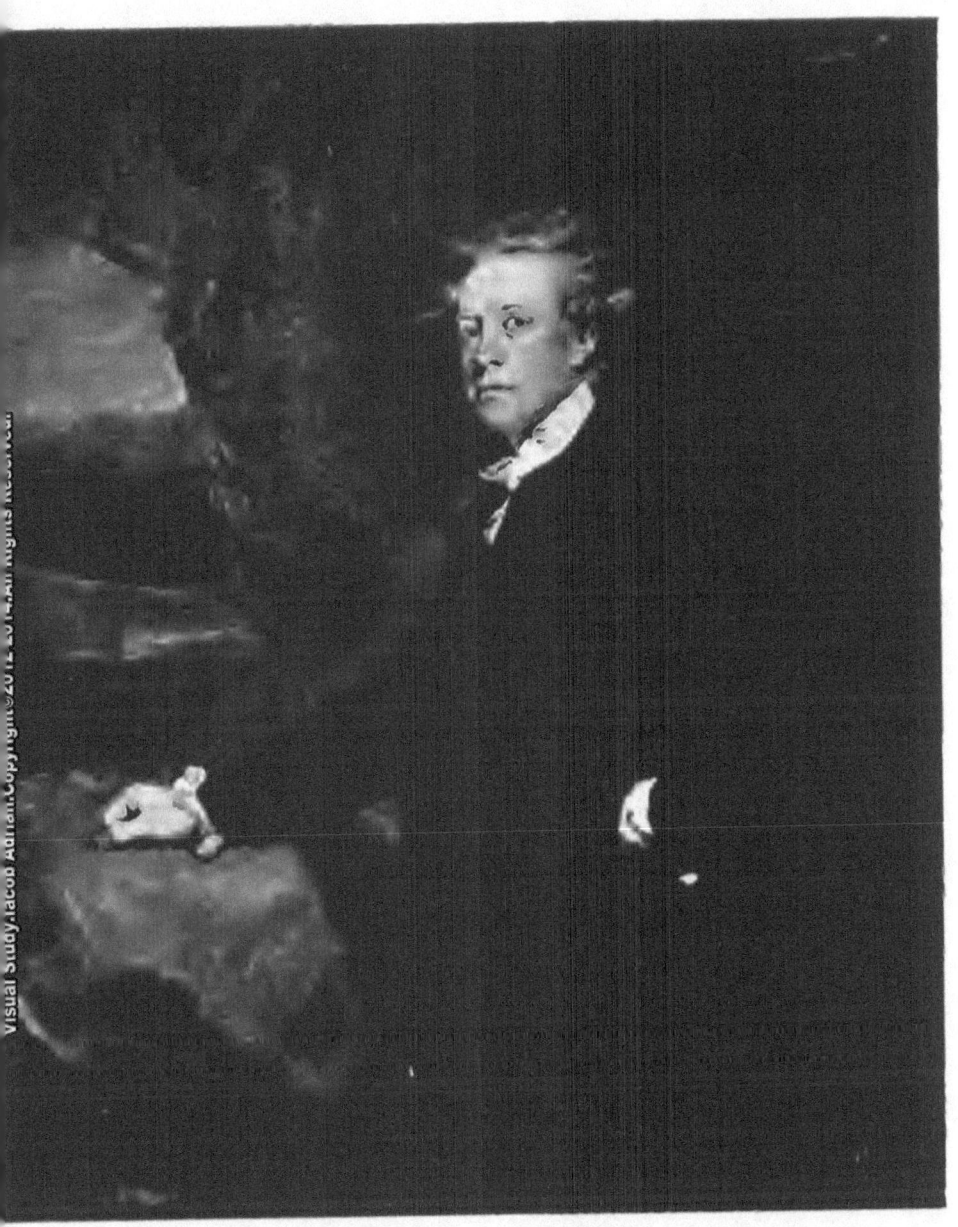

LORD RICHARD CAVENDISH LORD RICHARD CAVENDISH
(Duke of Devonshire, London) (Duc de Devonshire, Londres)
LORD RICHARD CAVENDISH
(London, Herzog von Devonshire)
F. Hanfstaengl, Photo.

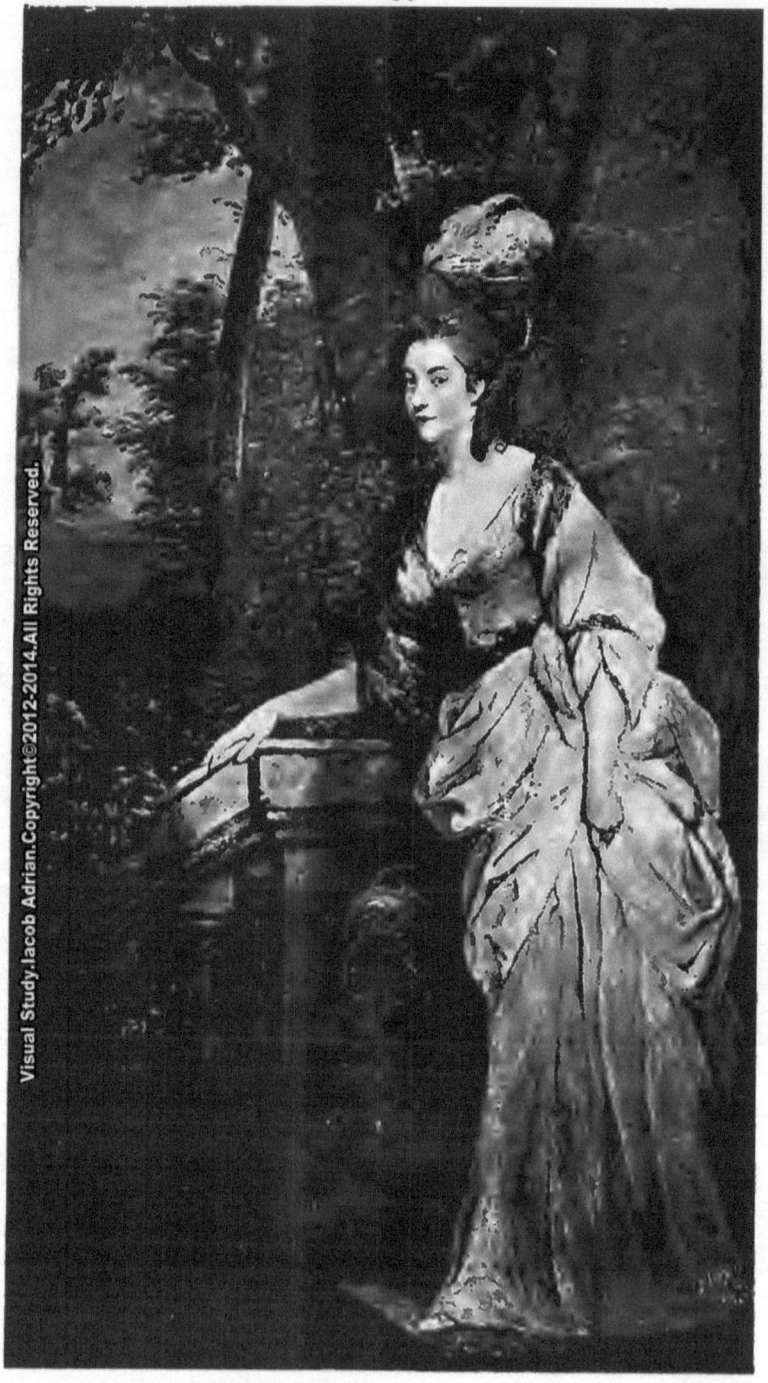

GEORGIANA, DUCHESS OF DEVONSHIRE GEORGIANA, DUCHESSE DE DEVONSHIRE
(*Earl Spencer, Althorp*) (*Comte Spencer, Althorp*)
GEORGIANA, HERZOGIN VON DEVONSHIRE
(*Althorp, Graf Spencer*) F. Hanfstaengl, Photo.

GEORGIANA, DUCHESS OF DEVONSHIRE GEORGIANA, DUCHESSE DE DEVONSHIRE
AND HER CHILD ET SON ENFANT
(Duke of Devonshire, Chatsworth) (Duc de Devonshire, Chatsworth)
GEORGIANA, HERZOGIN VON DEVONSHIRE, MIT IHREM KINDE
(Chatsworth, Herzog von Devonshire) F. Hanfstaengl, Photo.

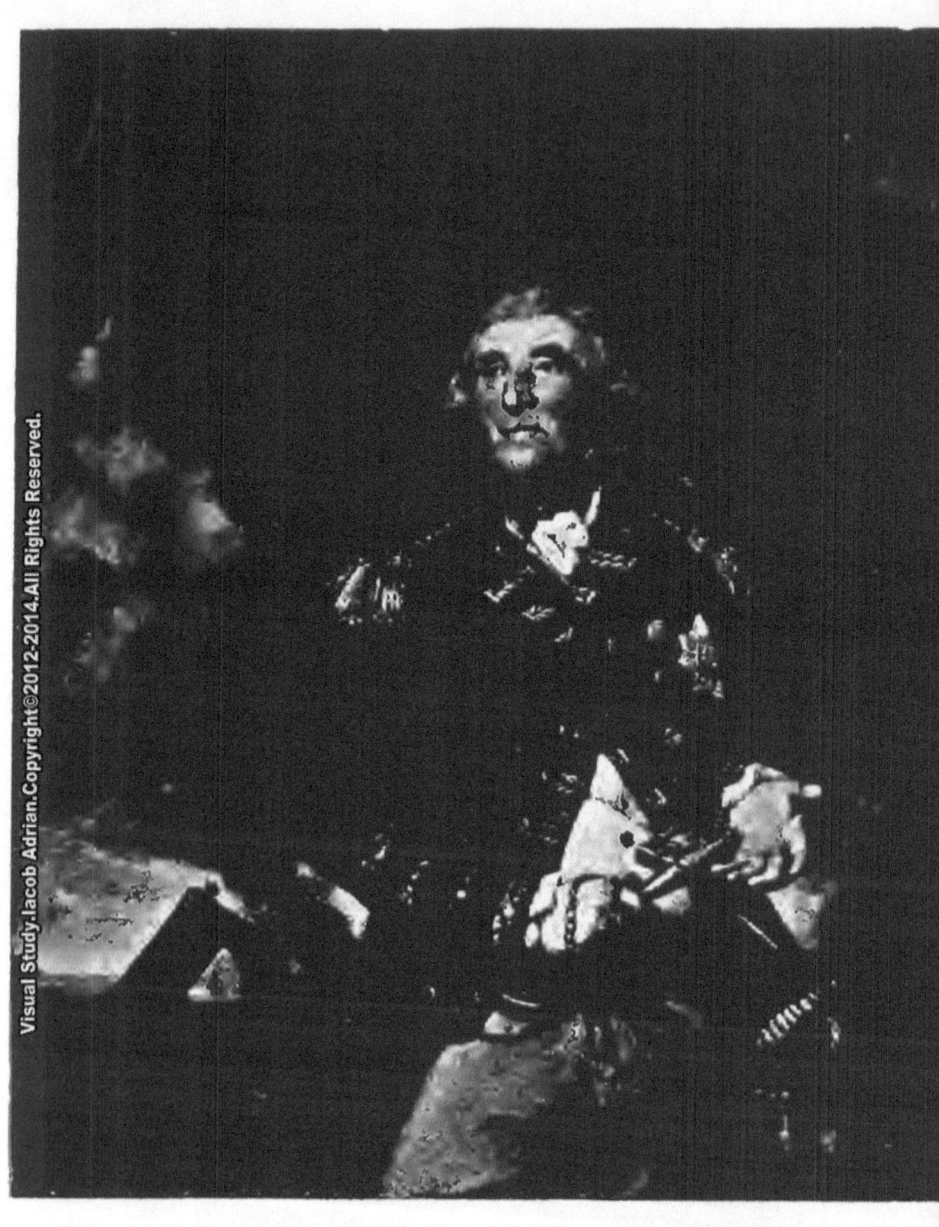

LORD HEATHFIELD
(*National Gallery, London*)

LORD HEATHFIELD
(*Galerie nationale, Londres*)

BILDNIS DES LORD HEATHFIELD
(*London, Nationalgalerie*)
F. *Hanfstaengl, Photo.*

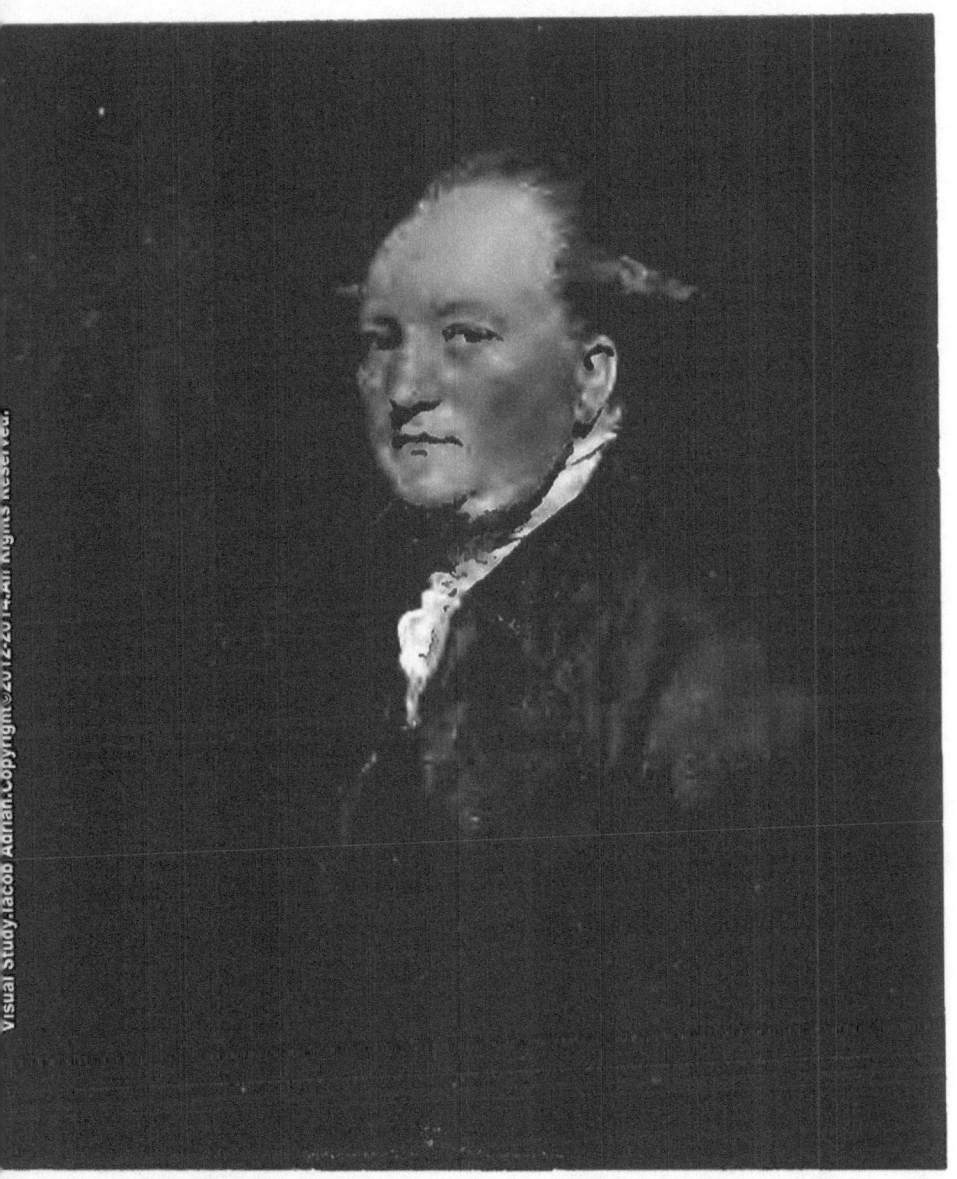

CHARLES,
FIRST EARL OF LUCAN
(*Earl Spencer, Althorp*)

CHARLES,
PREMIER COMTE DE LUCAN
(*Comte Spencer, Althorp*)

CHARLES, ERSTER GRAF VON LUCAN
(*Althorp, Graf Spencer*)
F. Hanfstaengl, Photo.

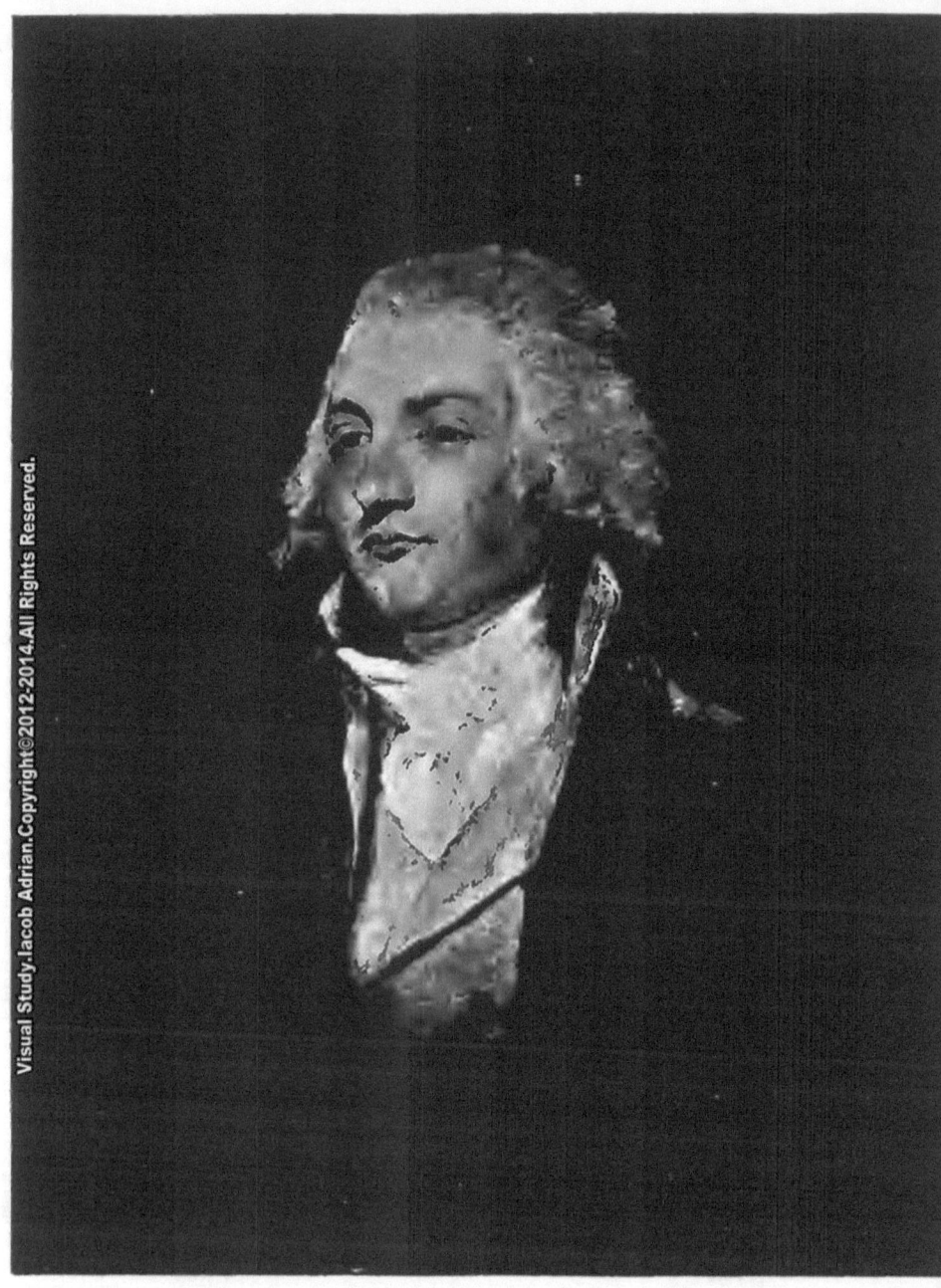

RICHARD,
SECOND EARL OF LUCAN
(*Earl Spencer, Althorp*)

RICHARD,
SECOND COMTE DE LUCAN
(*Comte Spencer, Althorp*)

RICHARD, ZWEITER GRAF VON LUCAN
(*Althorp, Graf Spencer*)
F. Hanfstaengl, Photo.

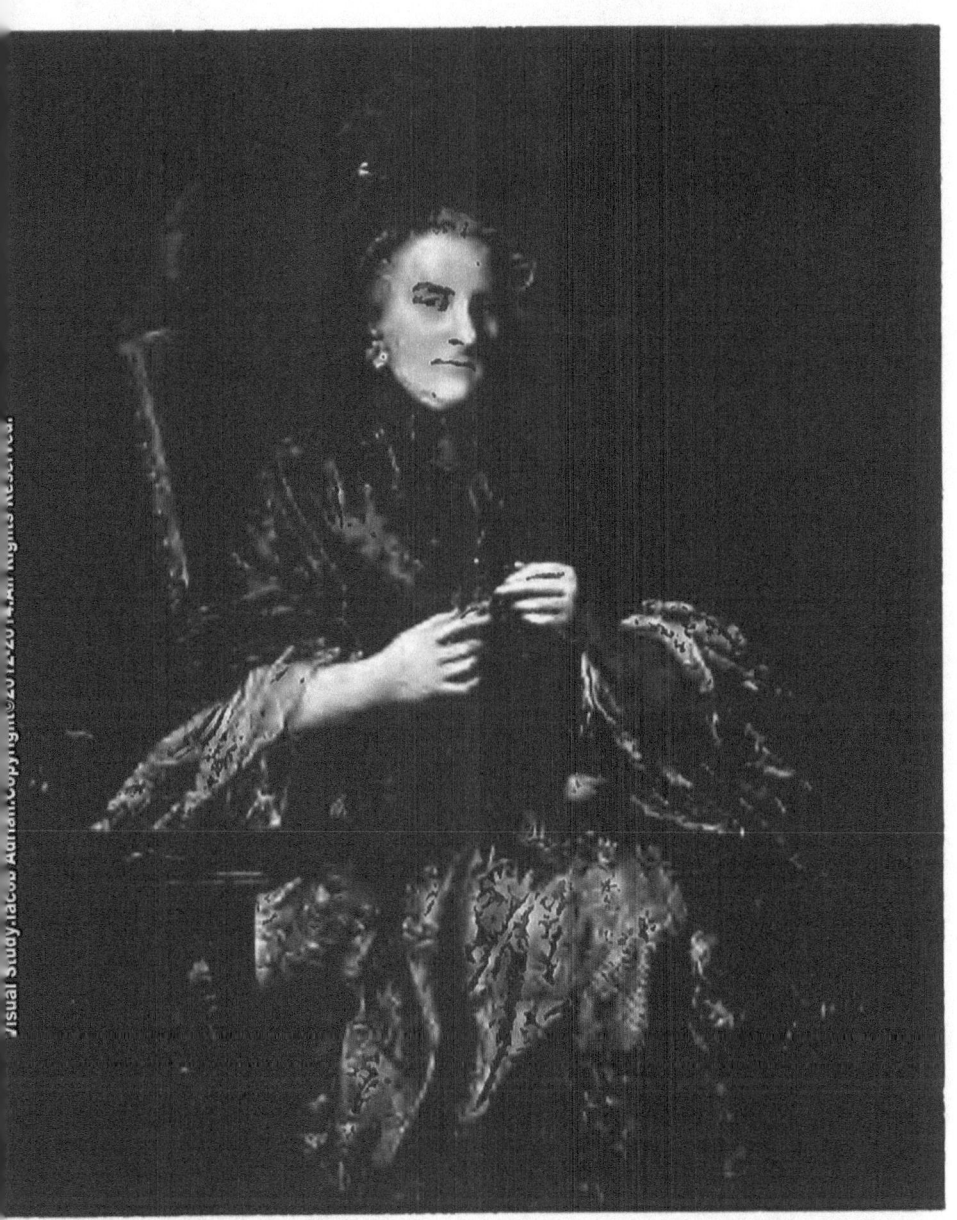

ANNE, COUNTESS OF ALBEMARLE ANNE, COMTESSE D'ALBEMARLE
(*National Gallery, London*) (*Galerie nationale, Londres*)
ANNA, GRÄFIN VON ALBEMARLE
(*London, Nationalgalerie*)
F. Hanfstuengl, Photo.

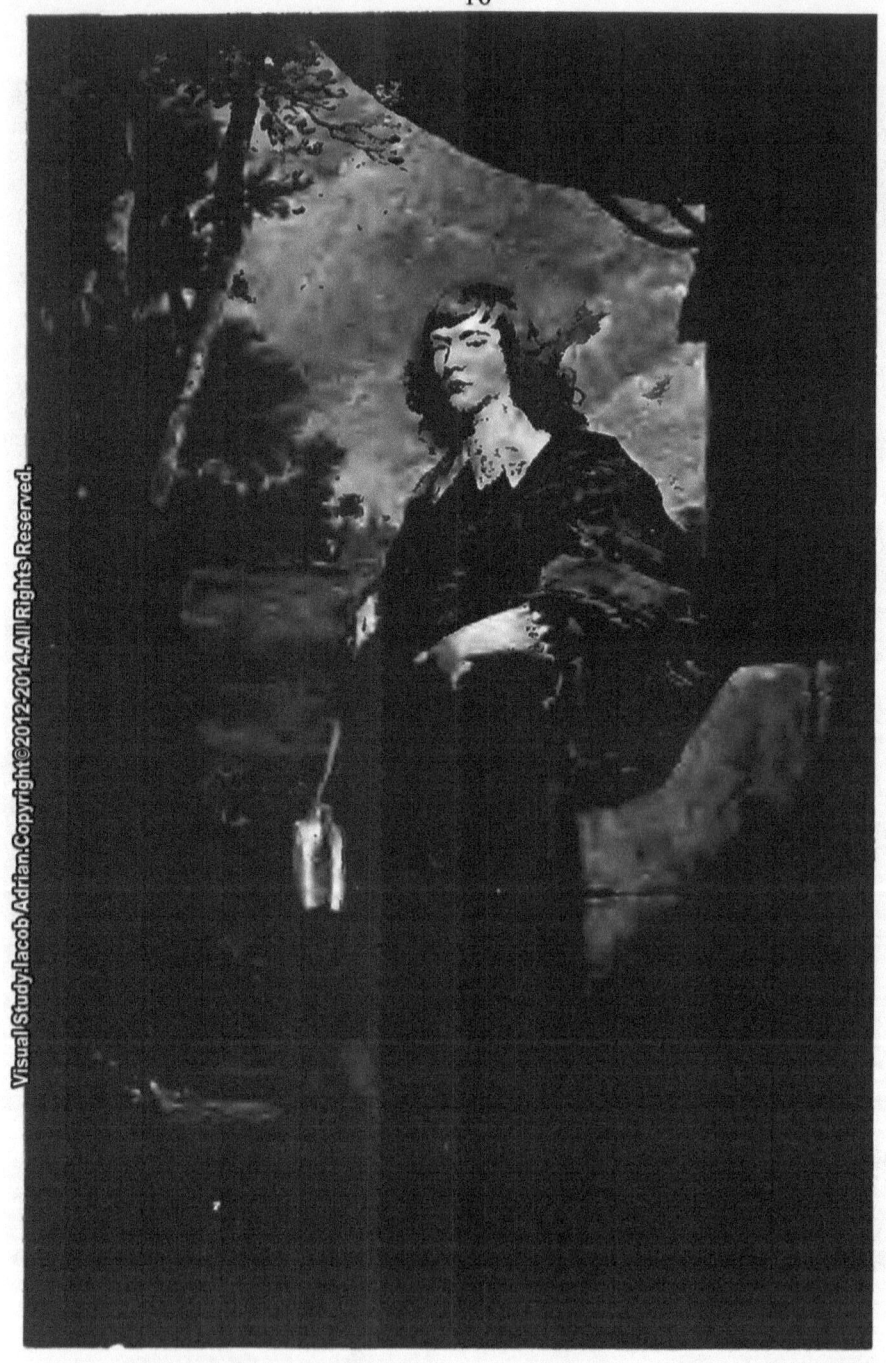

GEORGE JOHN, VISCOUNT ALTHORP,
AGED 17
(*Earl Spencer, Althorp*)

GEORGE JOHN, VICOMTE ALTHORP,
ÂGÉ DE DIX-SEPT ANS
(*Comte Spencer, Althorp*)

GEORGE JOHN, VISCOUNT ALTHORP 17 JAHRE ALT
(*Althorp, Graf Spencer*) F. *Hanfstaengl, Phot.*

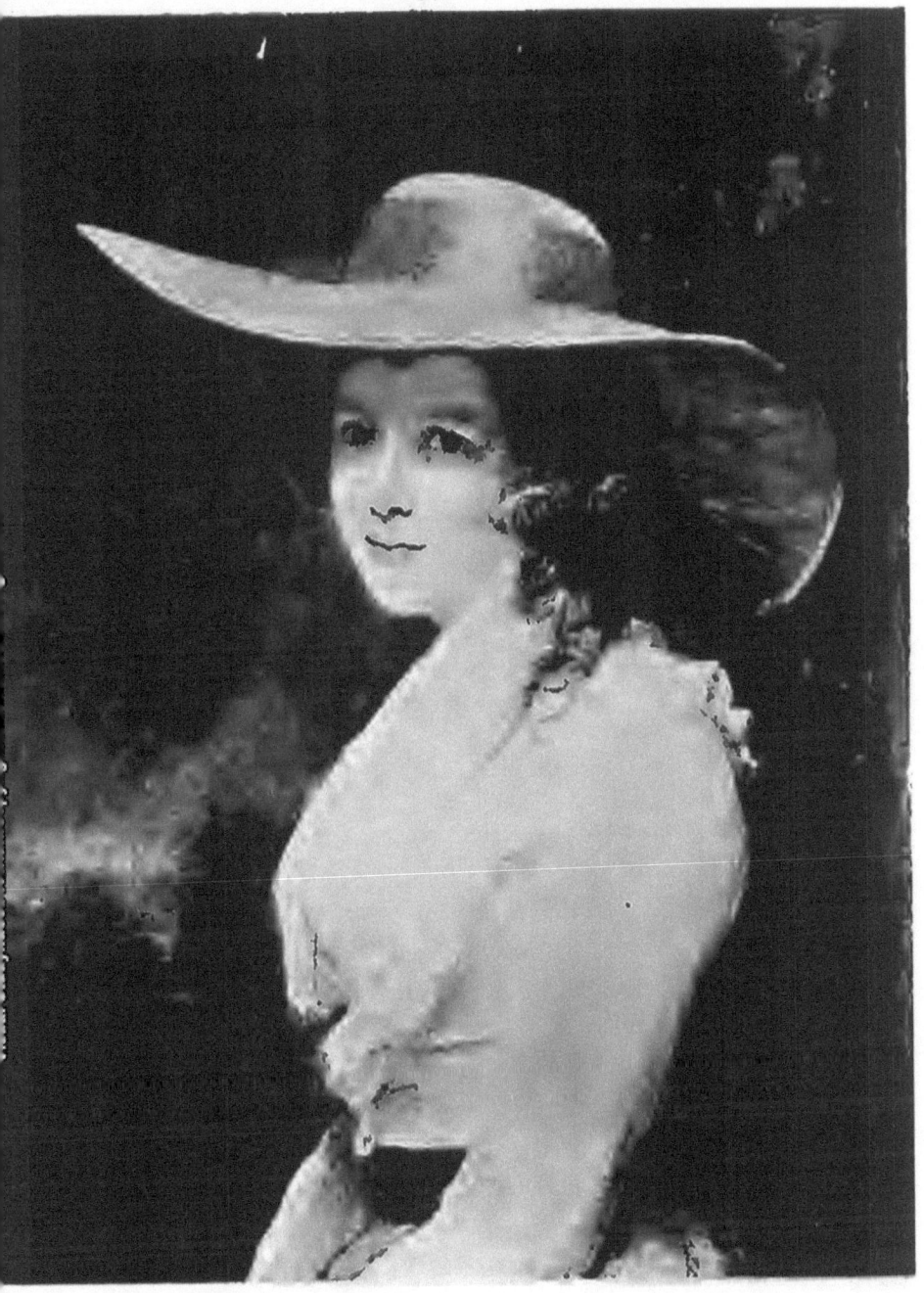

Lavinia, Countess Spencer
(Earl Spencer, Althorp)

Lavinia, Comtesse Spencer
(Comte Spencer, Althorp)

Lavinia, Gräfin Spencer
(Althorp, Graf Spencer)

F. Hanfstaengl, Photo.

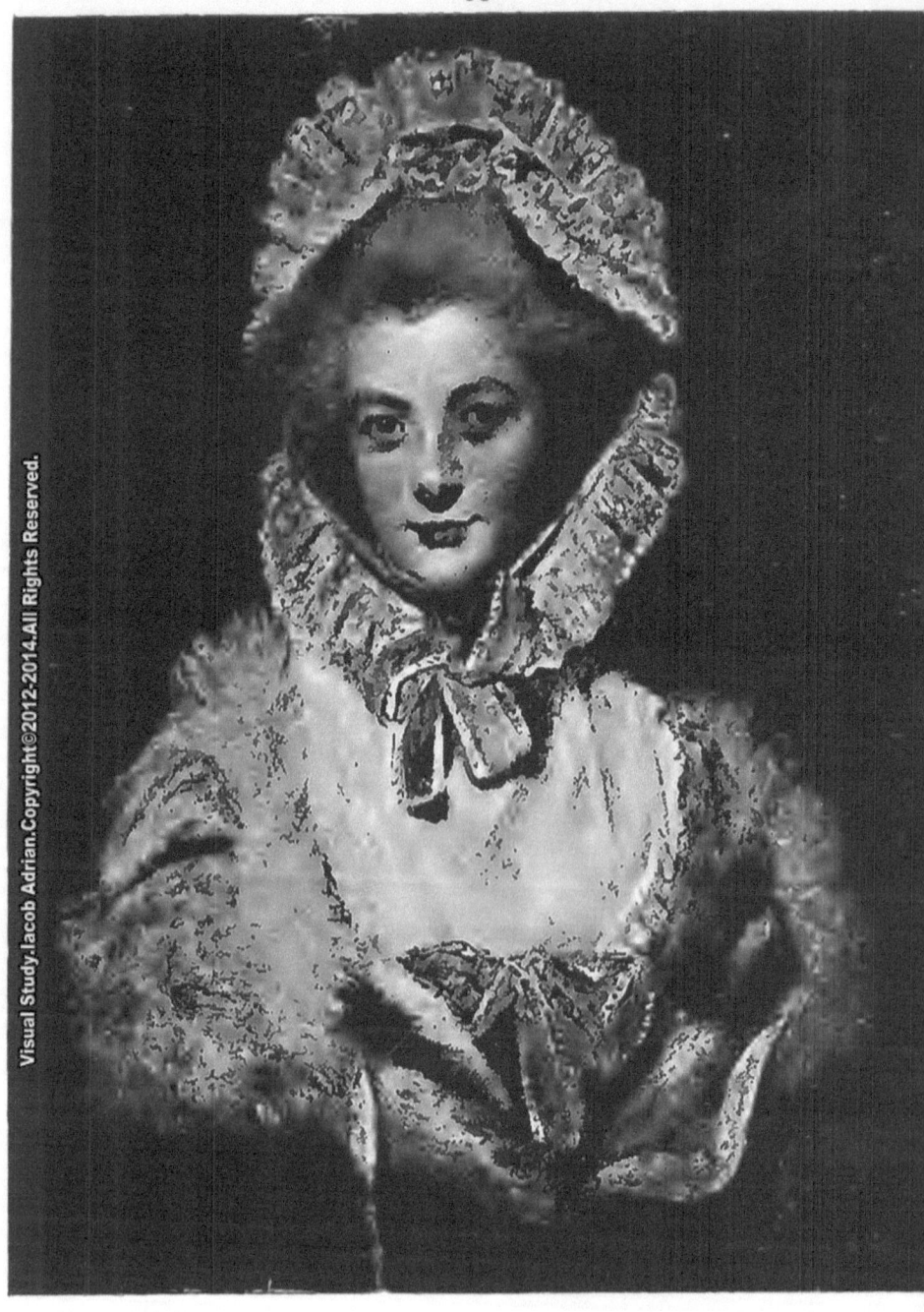

LAVINIA, COUNTESS SPENCER LAVINIA, COMTESSE SPENCER
(*Earl Spencer, Althorp*) (*Comte Spencer, Althorp*)
LAVINIA, GRÄFIN SPENCER
(*Althorp, Graf Spencer*)
F. Hanfstaengl, Photo.

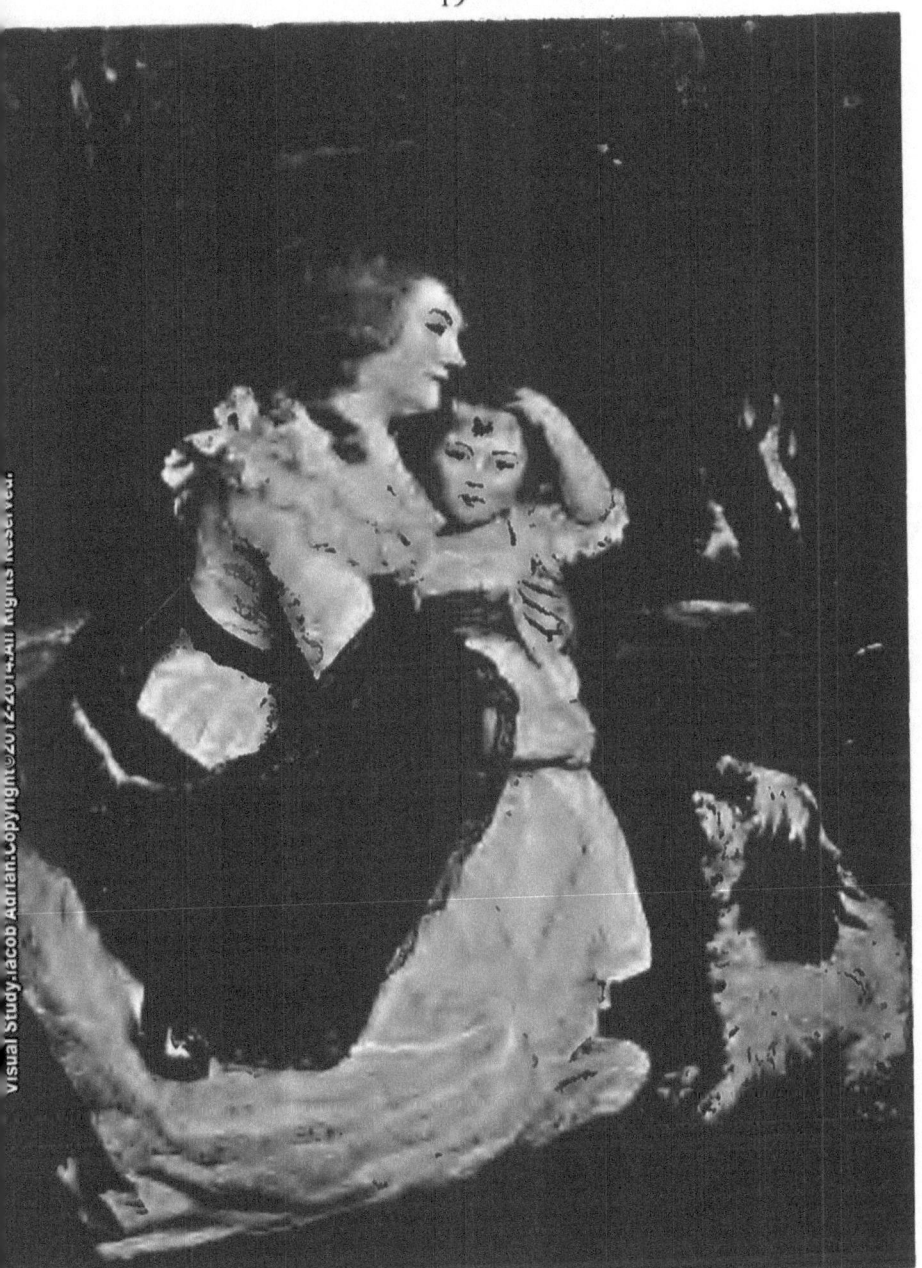

LAVINIA, COUNTESS SPENCER AND HER SON JOHN CHARLES, VISCOUNT ALTHORP
(Earl Spencer, Althorp)

LAVINIA, COMTESSE SPENCER ET SON FILS JOHN CHARLES, VICOMTE ALTHORP
(Comte Spencer, Althorp)

LAVINIA, GRÄFIN SPENCER UND IHR SOHN JOHN CHARLES, VISCOUNT ALTHORP
(Althorp, Graf Spencer) F. Hanfstaengl, Photo.

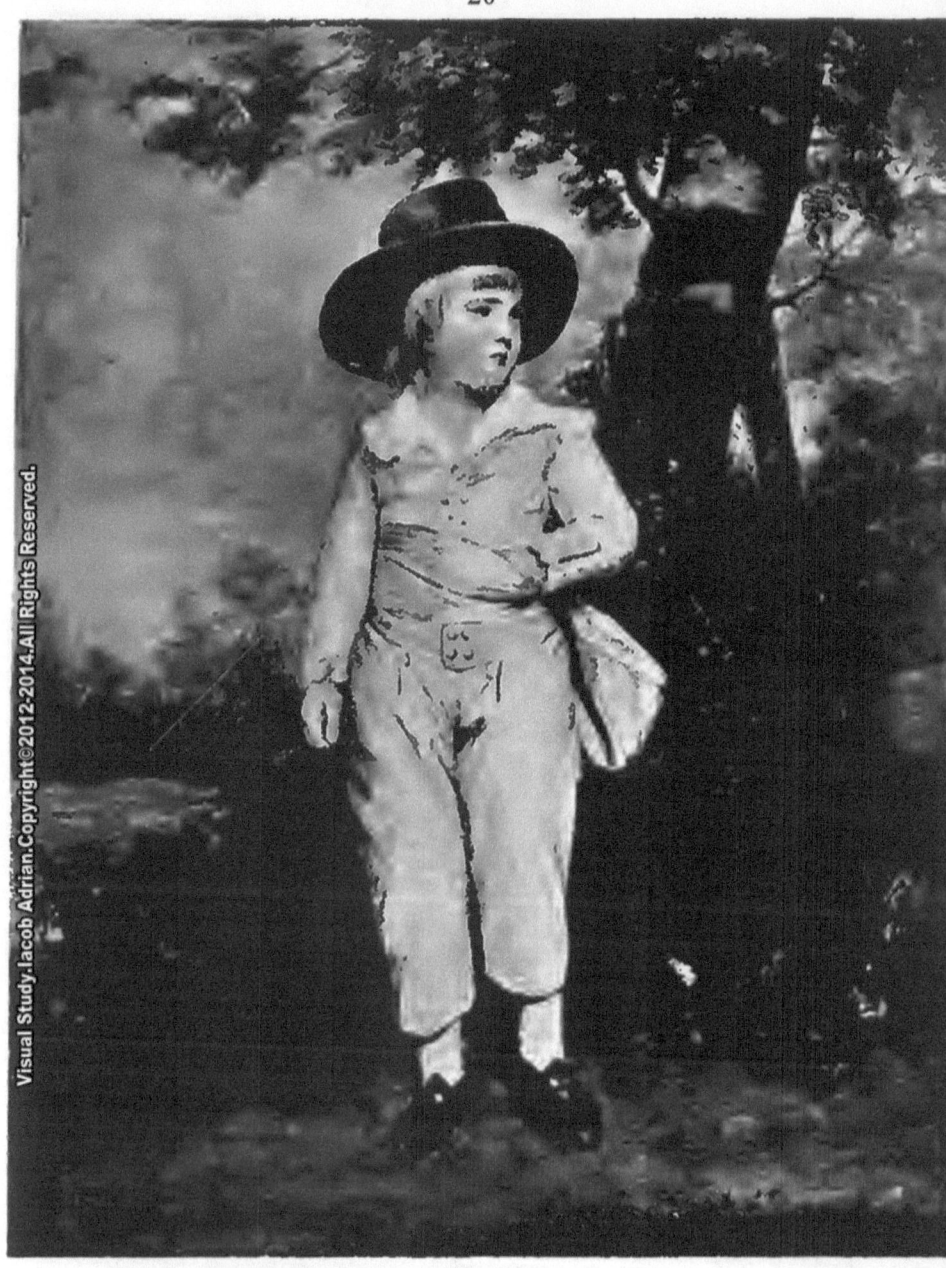

JOHN CHARLES,
VISCOUNT ALTHORP
AGED FOUR YEARS
(*Earl Spencer, Althorp*)

JOHN CHARLES,
VICOMTE ALTHORP,
ÂGÉ DE QUATRE ANS
(*Comte Spencer, Althorp*)

JOHN CHARLES, VISCOUNT ALTHORP, 4 JAHRE ALT
(*Althorp, Graf Spencer*)
F. Hanfstaengl, Photo.

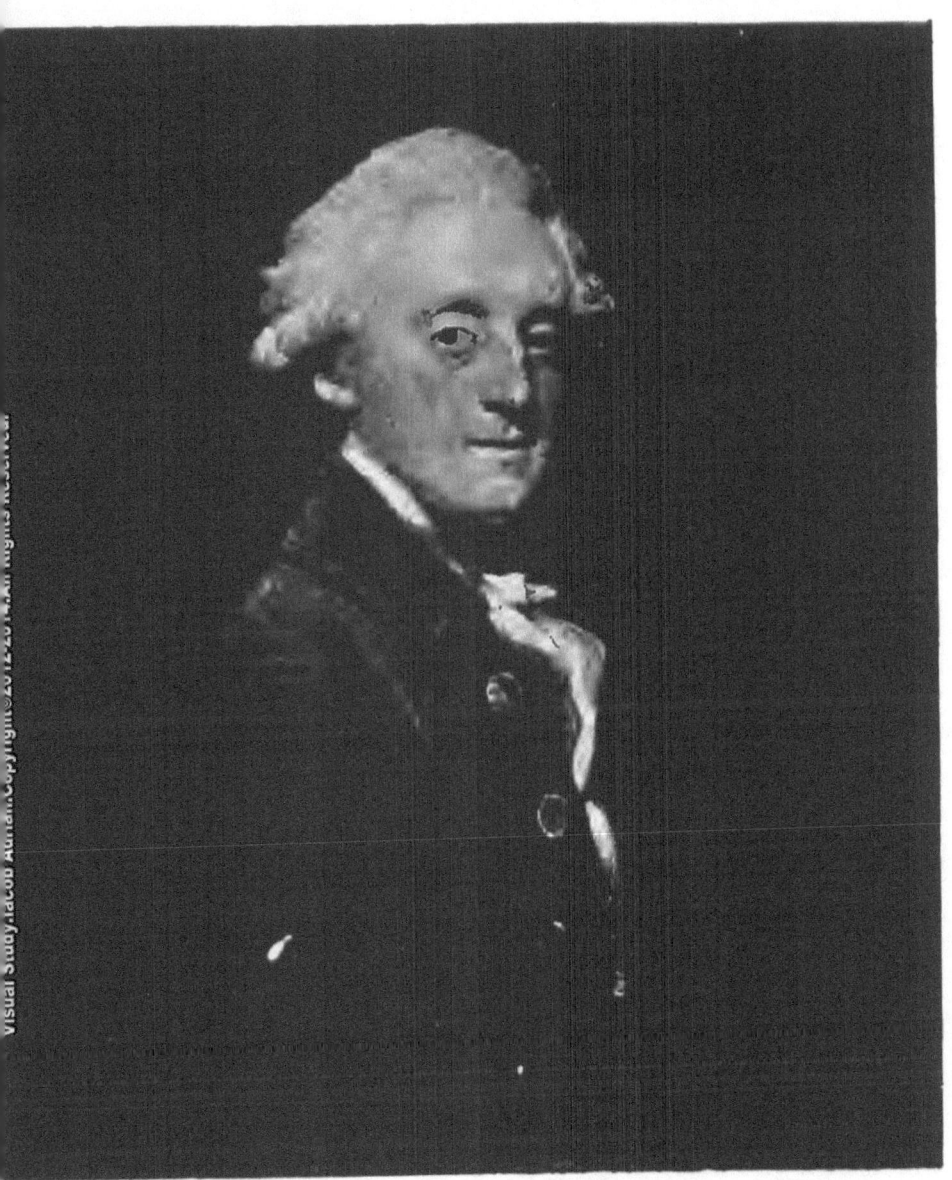

FREDERICK,
EARL OF BESSBOROUGH
(*Earl Spencer, Althorp*)

FREDERICK,
COMTE DE BESSBOROUGH
(*Comte Spencer, Althorp*)

FREDERICK, GRAF VON BESSBOROUGH
(*Althorp, Graf Spencer*)
F. Hanfstaengl, Photo.

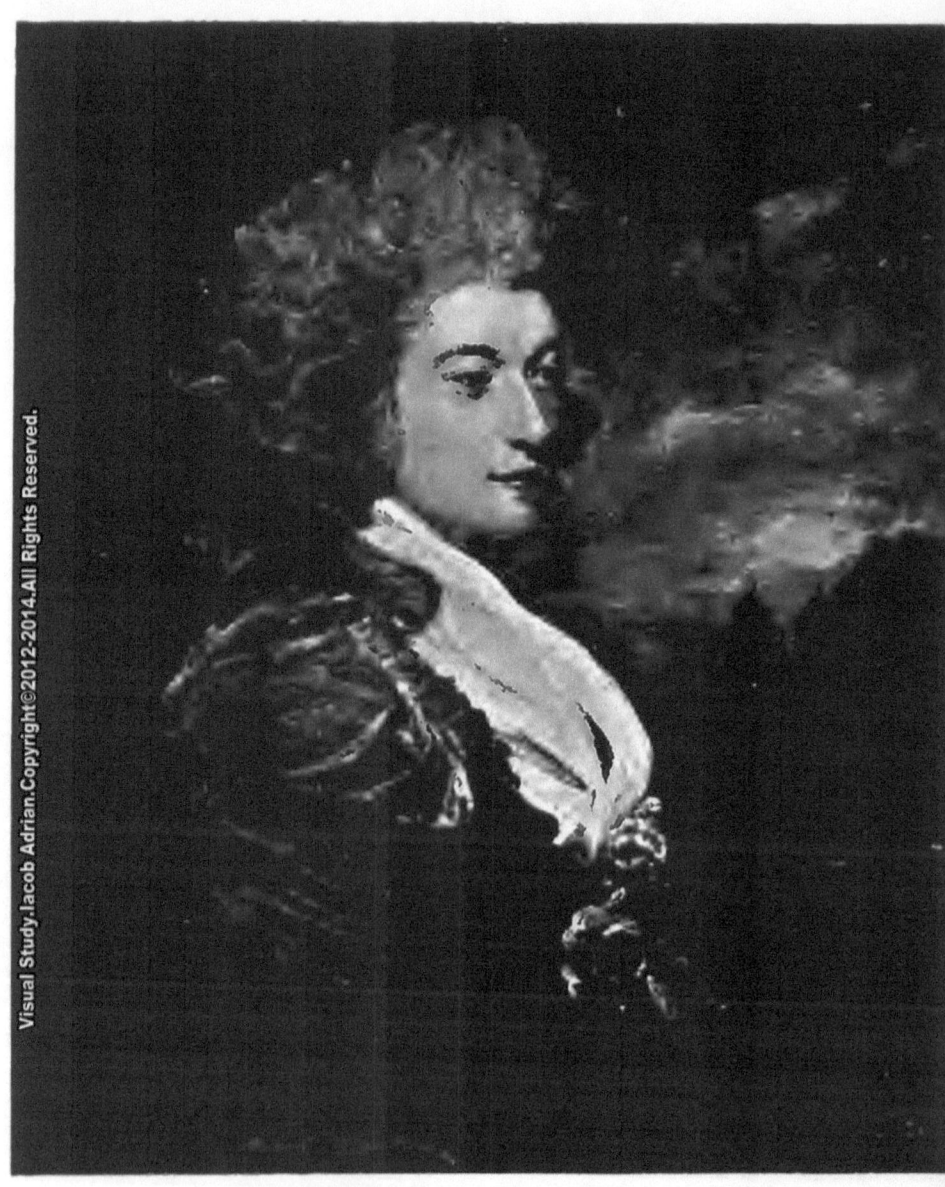

HENRIETTA FRANCES, COUNTESS OF BESSBOROUGH
(*Earl Spencer, Althorp*)

HENRIETTA FRANCES, COMTESSE DE BESSBOROUGH
(*Comte Spencer, Althorp*)

HENRIETTA FRANCES, GRÄFIN VON BESSBOROUGH
(*Althorp, Graf Spencer*)

F. Hanfstaengl, Photo.

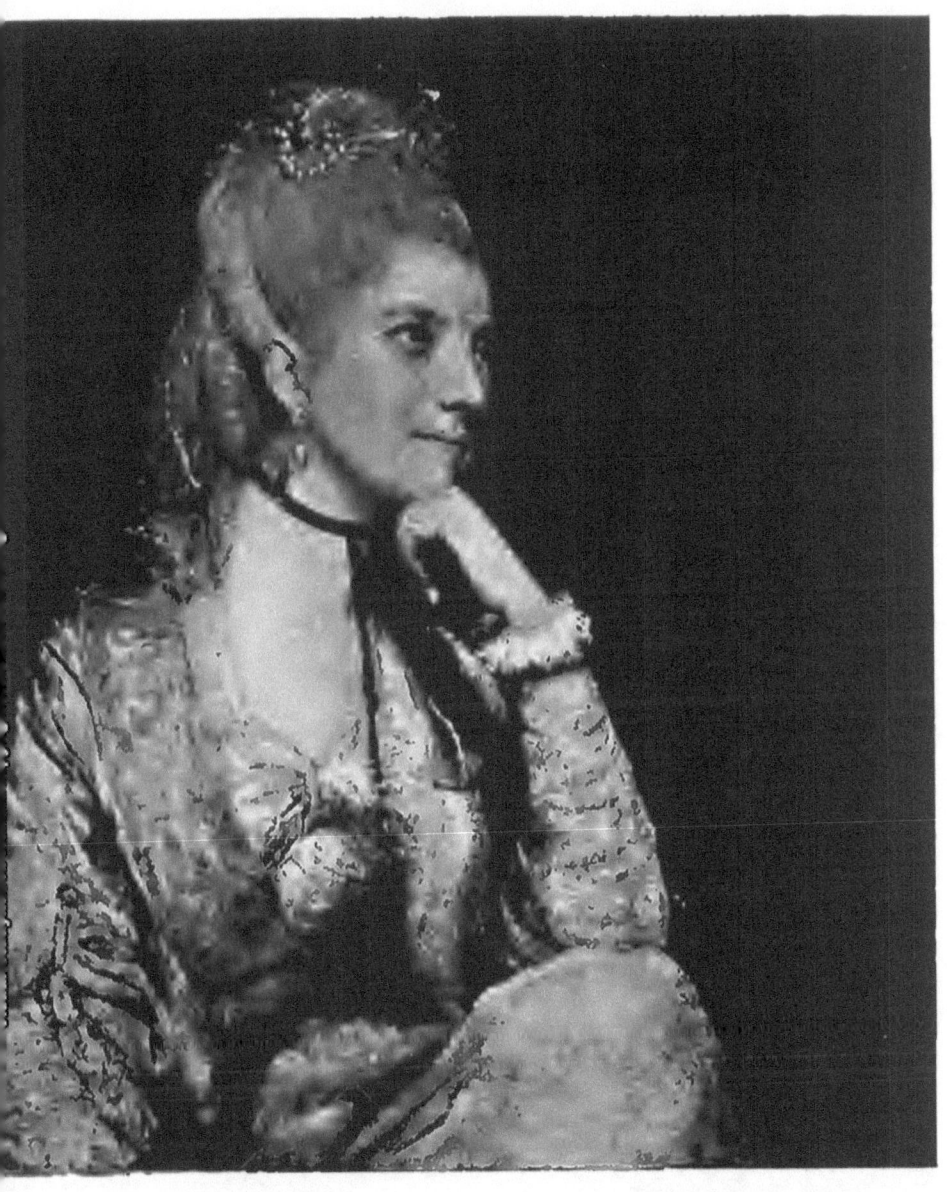

LA MARÉCHALE DE MUYS (CHANOINESSE) (Earl Spencer, Althorp)

LA MARÉCHALE DE MUYS (CHANOINESSE) (Comte Spencer, Althorp)

LA MARÉCHALE DE MUYS (STIFTSDAME) (Althorp, Graf Spencer)

F. Hanfstaengl, Photo.

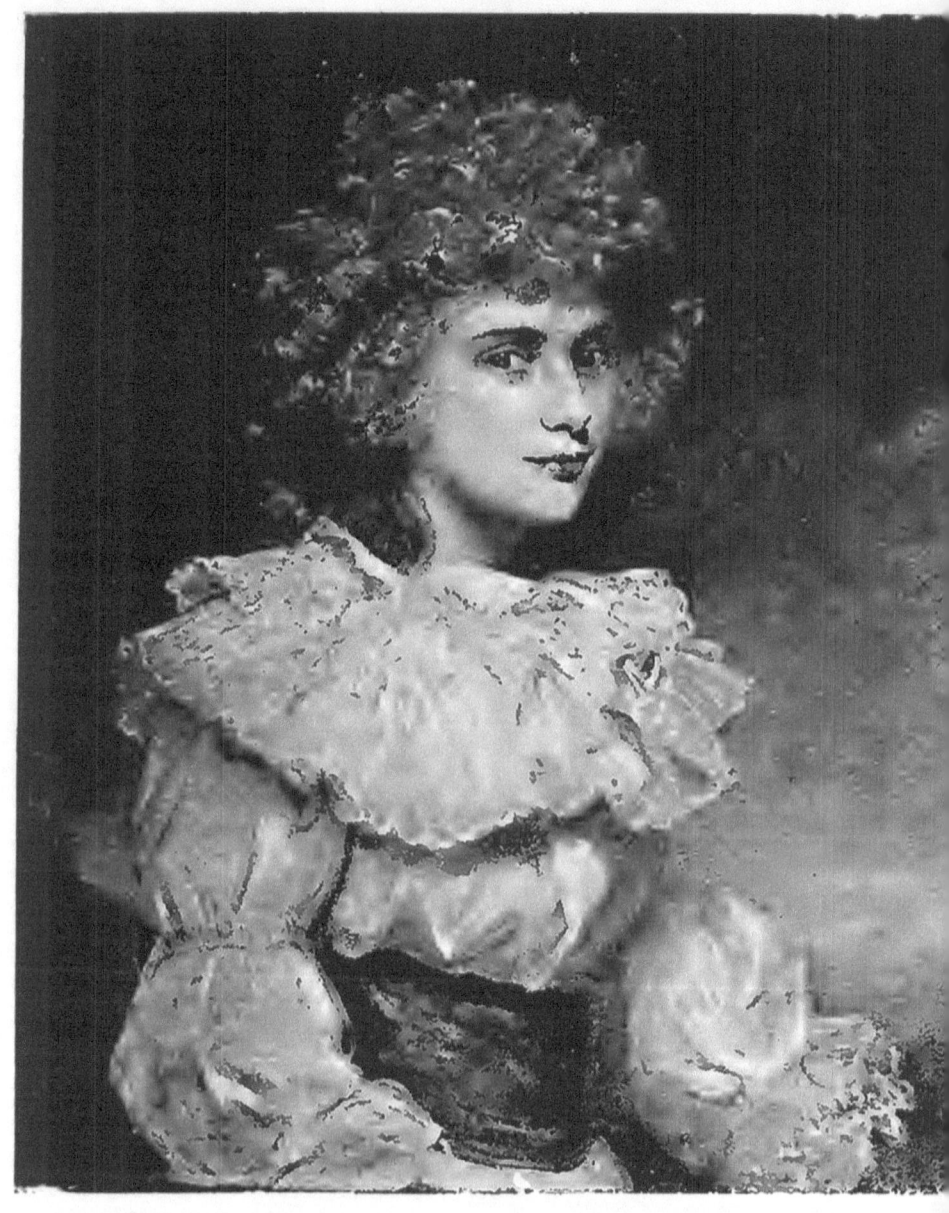

LADY BETTY FOSTER LADY BETTY FOSTER
(Duke of Devonshire, Chatsworth) (Duc de Devonshire, Chatsworth)
LADY BETTY FOSTER
(Chatsworth, Herzog von Devonshire)
F. Hanfstaengl, Photo.

25

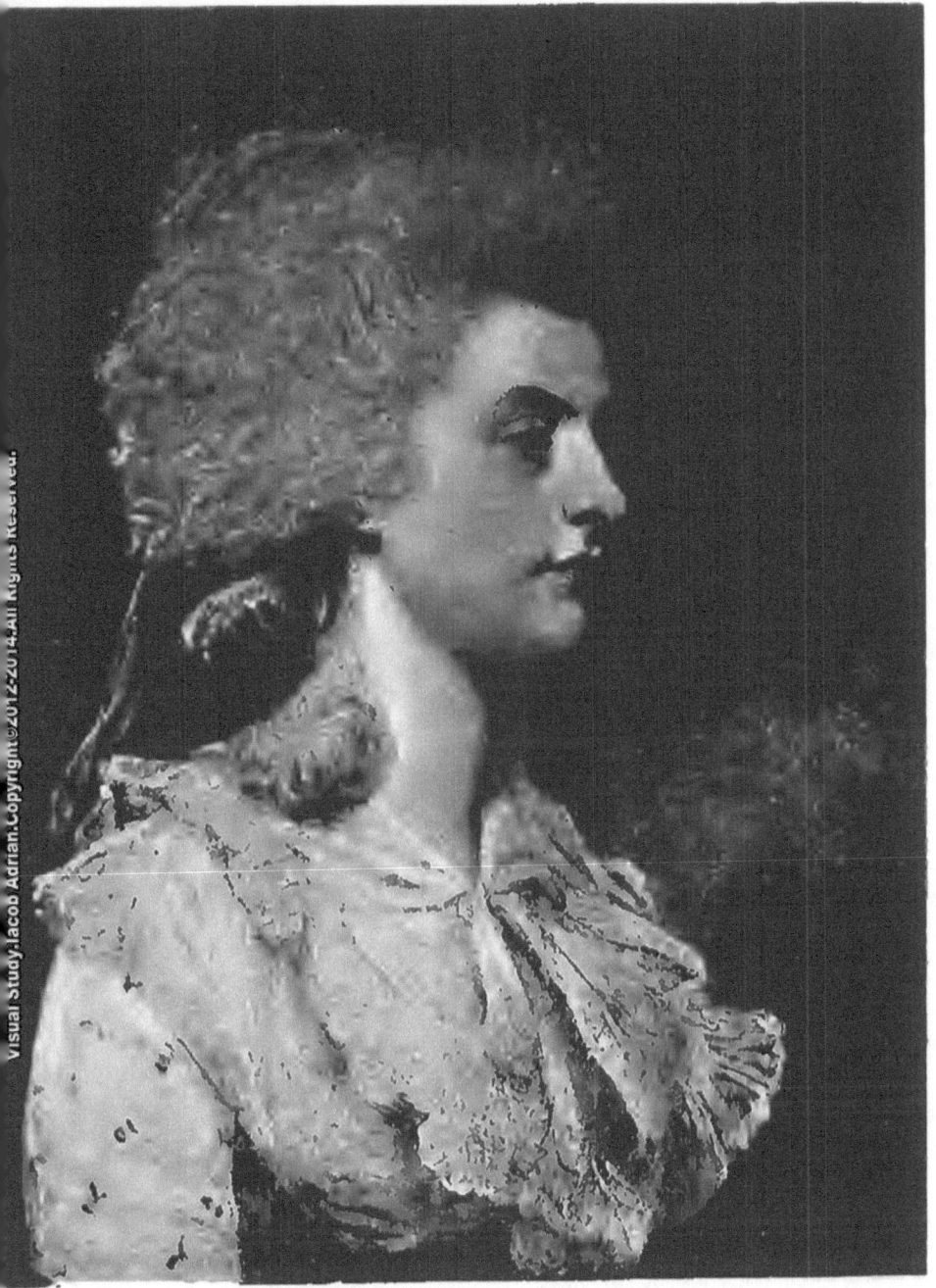

Lady Elizabeth Conway
(*Wallace Collection, London*)

Lady Elizabeth Conway
(*Collection Wallace, Londres*)

Lady Elizabeth Conway
(*London, Sammlung Wallace*)
F. Hanfstaengl, Photo.

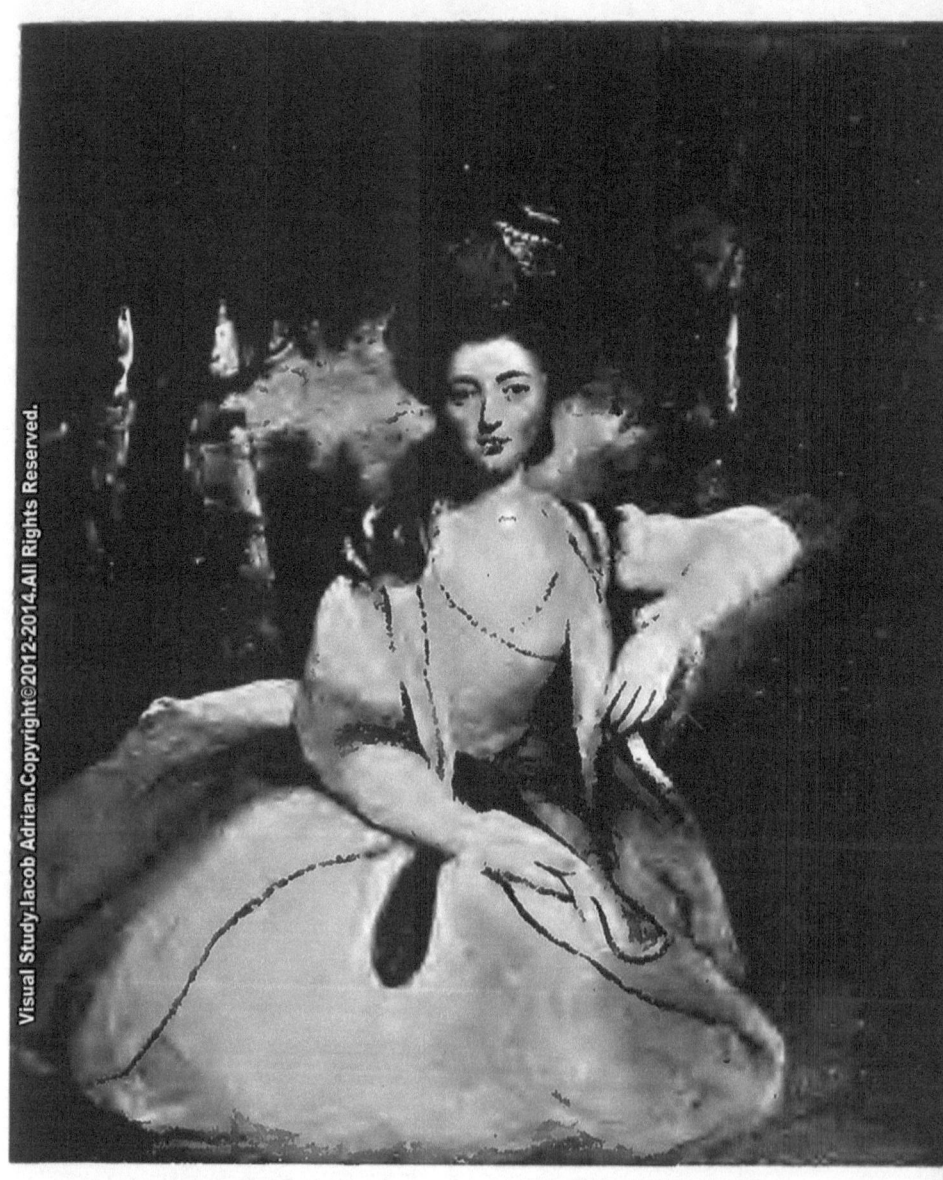

FRANCES,
MARCHIONESS OF CAMDEN
(*Earl Spencer, Althorp*)

FRANCES,
MARQUISE DE CAMDEN
(*Comte Spencer, Althorp*)

FRANCES, MARQUISE VON CAMDEN
(*Althorp, Graf Spencer*)

F. Hanfstaengl, Photo.

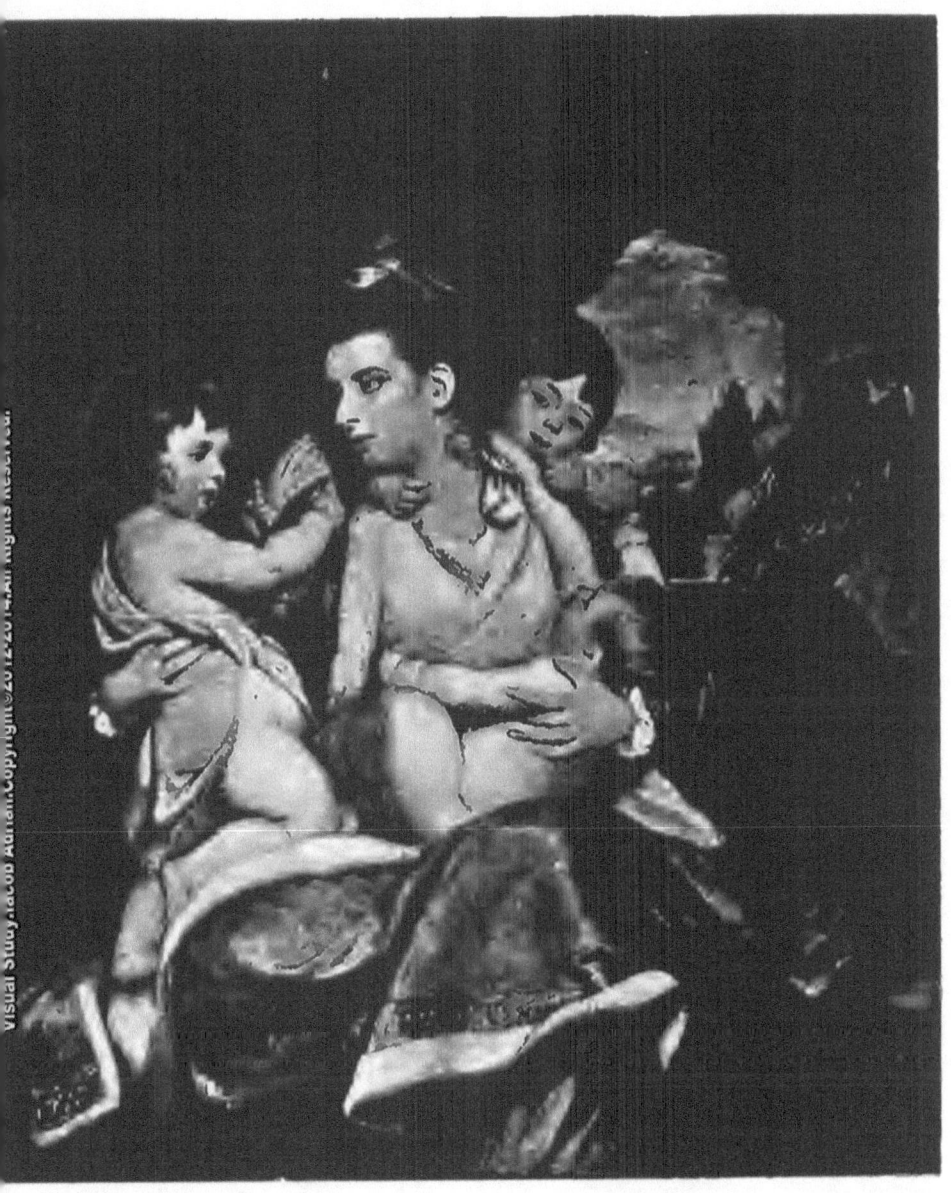

LADY COCKBURN AND HER CHILDREN
(*National Gallery, London*)

LADY COCKBURN ET SES ENFANTS
(*Galerie nationale, Londres*)

BILDNIS DER LADY COCKBURN MIT IHREN KINDERN
(*London, Nationalgalerie*)

F. *Hanfstaengl, Photo.*

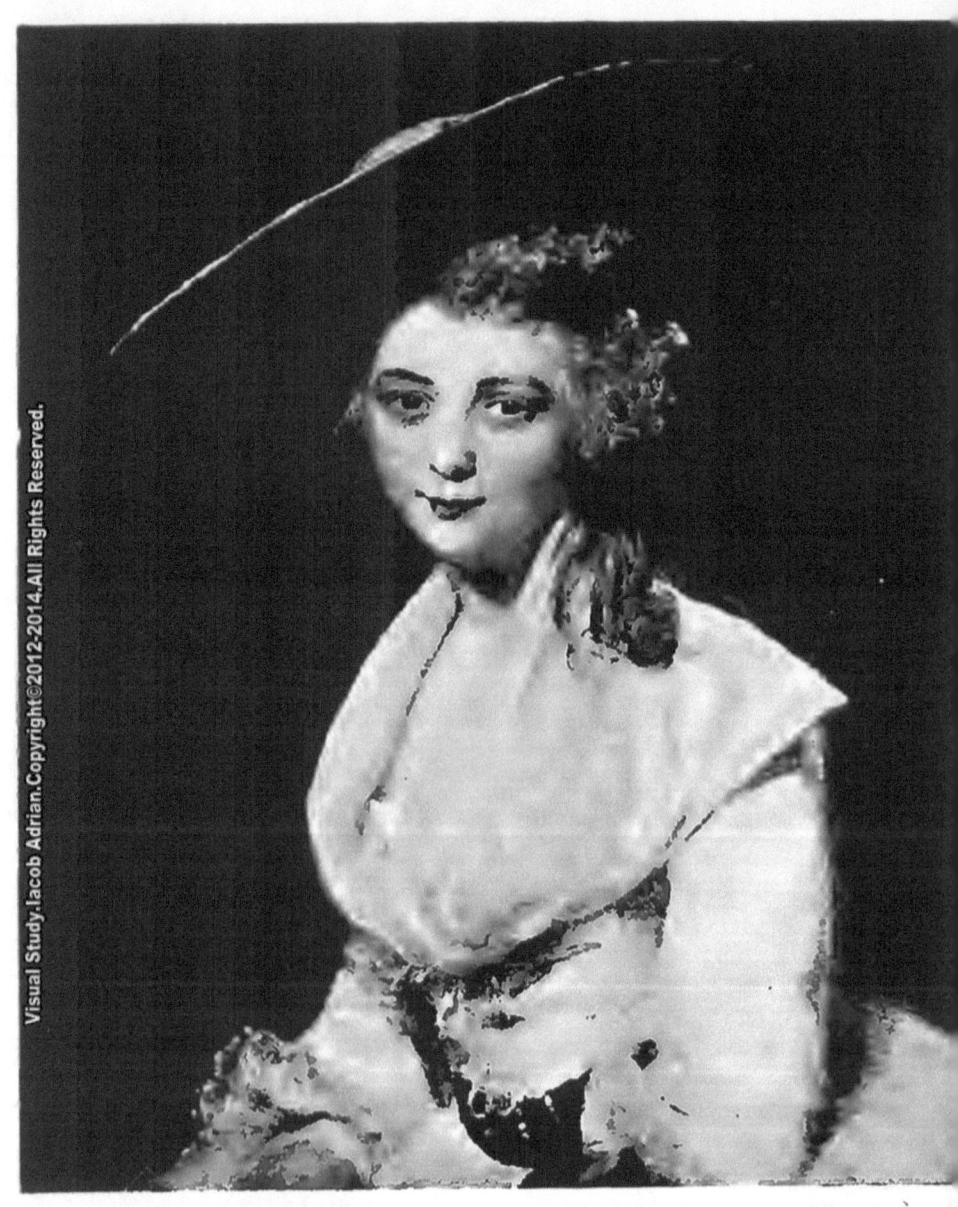

LADY ANN BINGHAM
(*Earl Spencer, Althorp*)

LADY ANN BINGHAM
(*Comte Spencer, Althorp*)

LADY ANN BINGHAM
(*Althorp, Graf Spencer*)
F. Hanfstaengl, Photo.

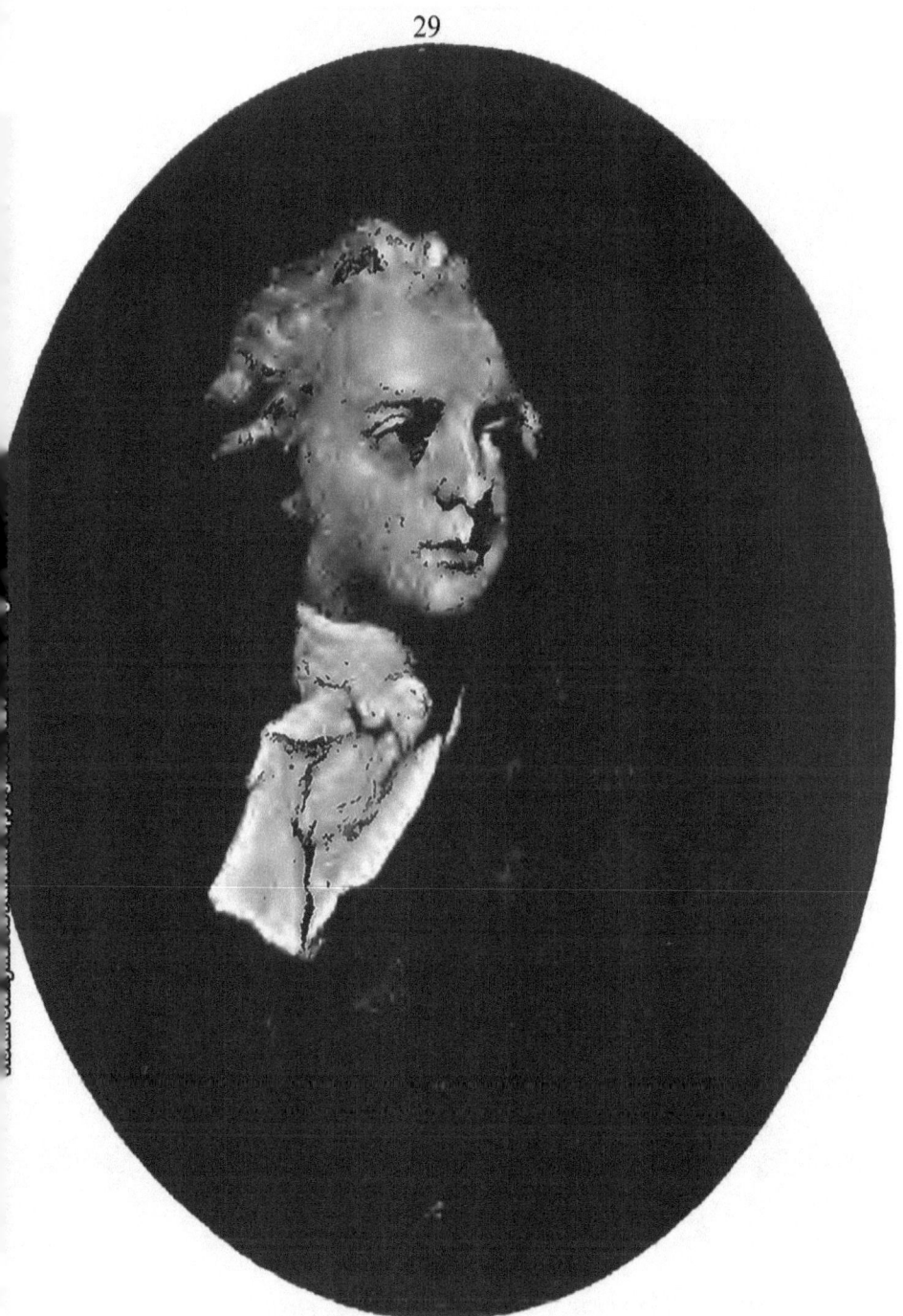

Sir Abraham Hume
(*National Gallery, London*)

Sir Abraham Hume
(*Galerie nationale, Londres*)

Bildnis des Abraham Hume
(*London, Nationalgalerie*)

F. *Hanfstaengl*, Photo.

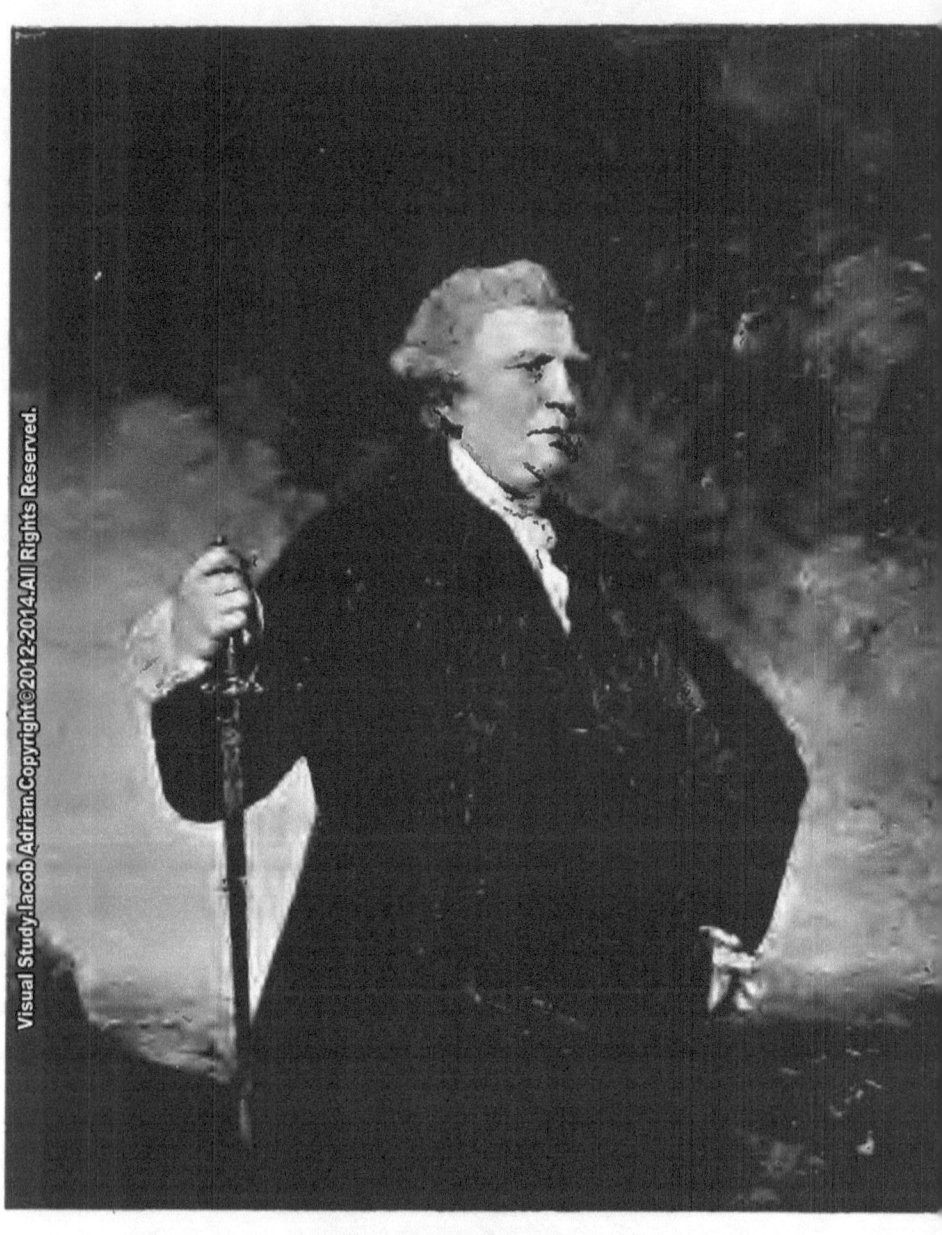

ADMIRAL KEPPEL L'AMIRAL KEPPEL
(*National Gallery, London*) (*Galerie nationale, Londres*)
ADMIRAL KEPPEL
(*London, Nationalgalerie*)
F. Hanfstaengl, Photo.

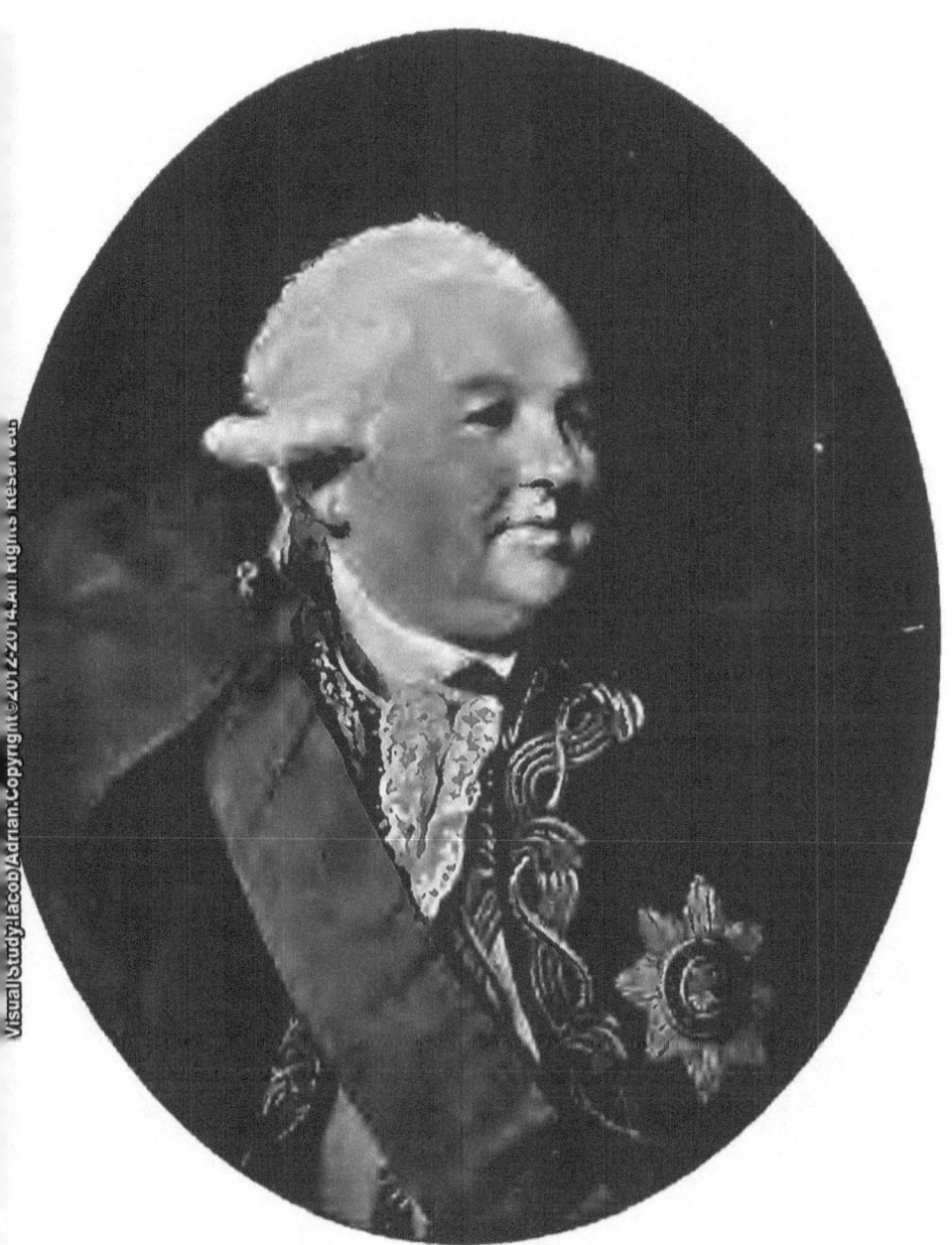

ADMIRAL HUGHES
(*Museum, Buda-Pesth*)

L'AMIRAL HUGHES
(*Musée, Buda-Pesth*)

ADMIRAL HUGHES
(*Budapest, Museum*)
F. *Hanfstaengl, Photo.*

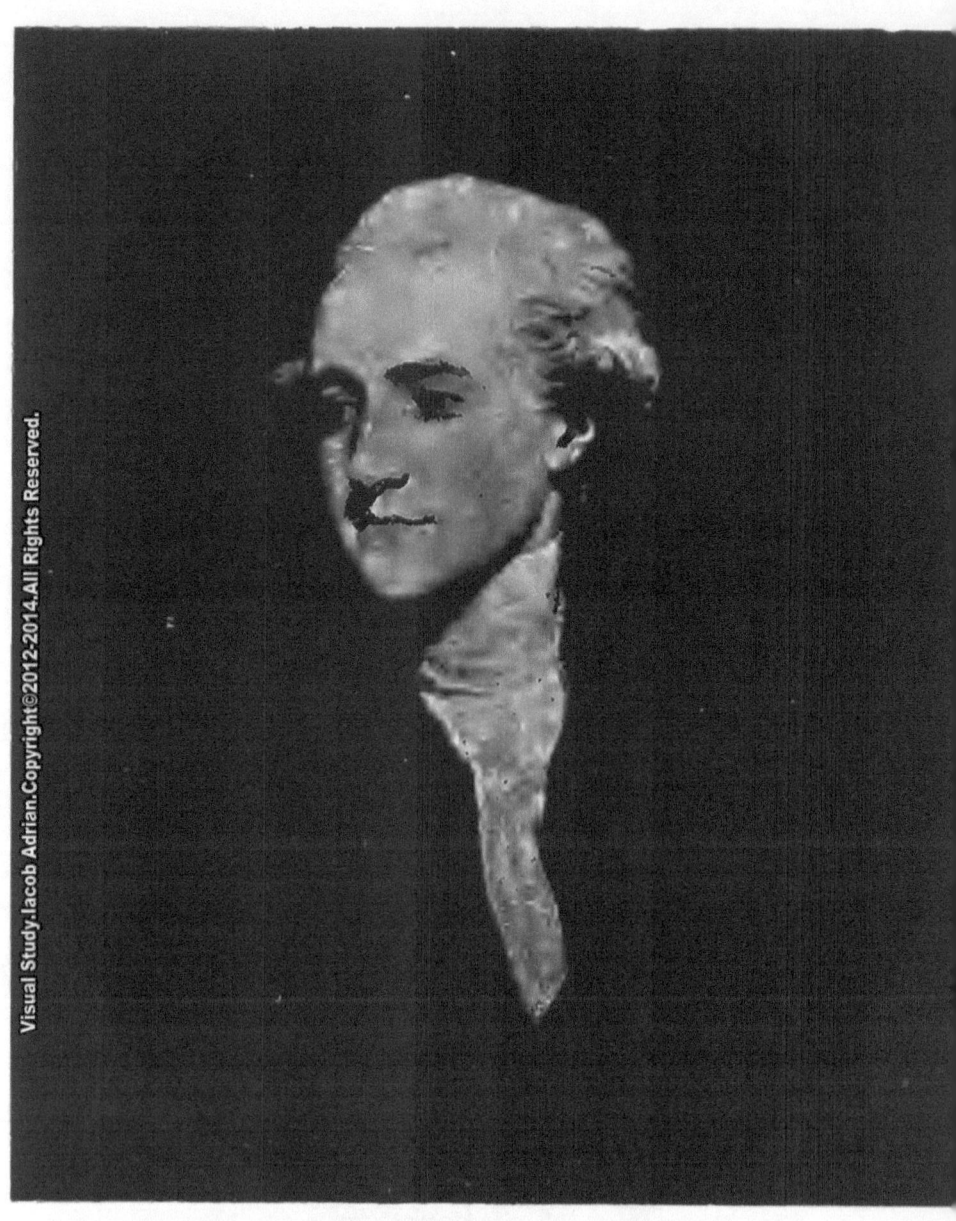

Dr. Richard Burke
(Earl Spencer, Althorp)

Dr. Richard Burke
(Comte Spencer, Althorp)

Dr. Richard Burke
(Althorp, Graf Spencer)
F. Hanfstaengl, Photo.

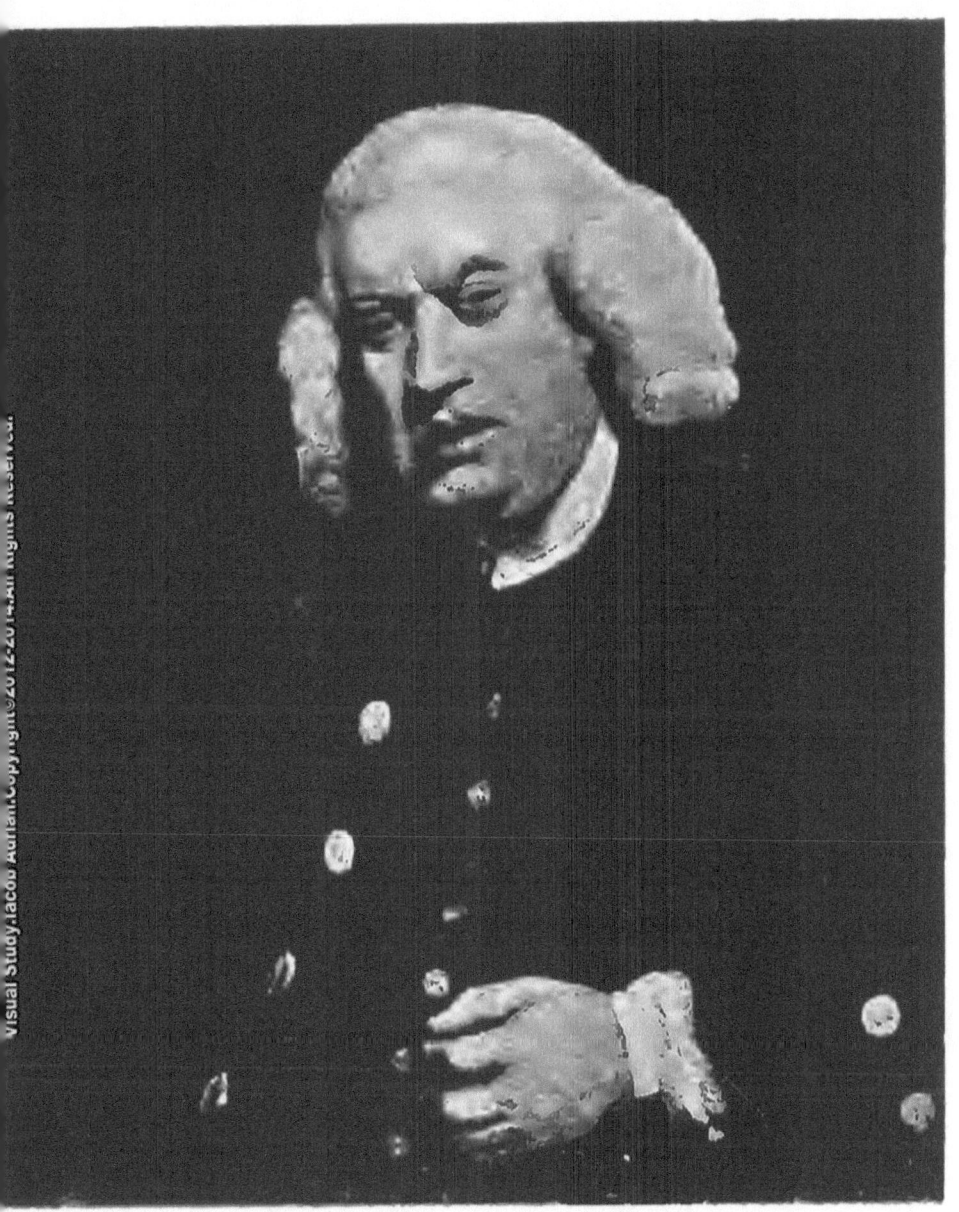

Dr. Samuel Johnson
(National Gallery, London)

Dr. Samuel Johnson
(Galerie nationale, Londres)

Dr. Samuel Johnson
(London, Nationalgalerie)

F. Hanfstaengl, Photo.

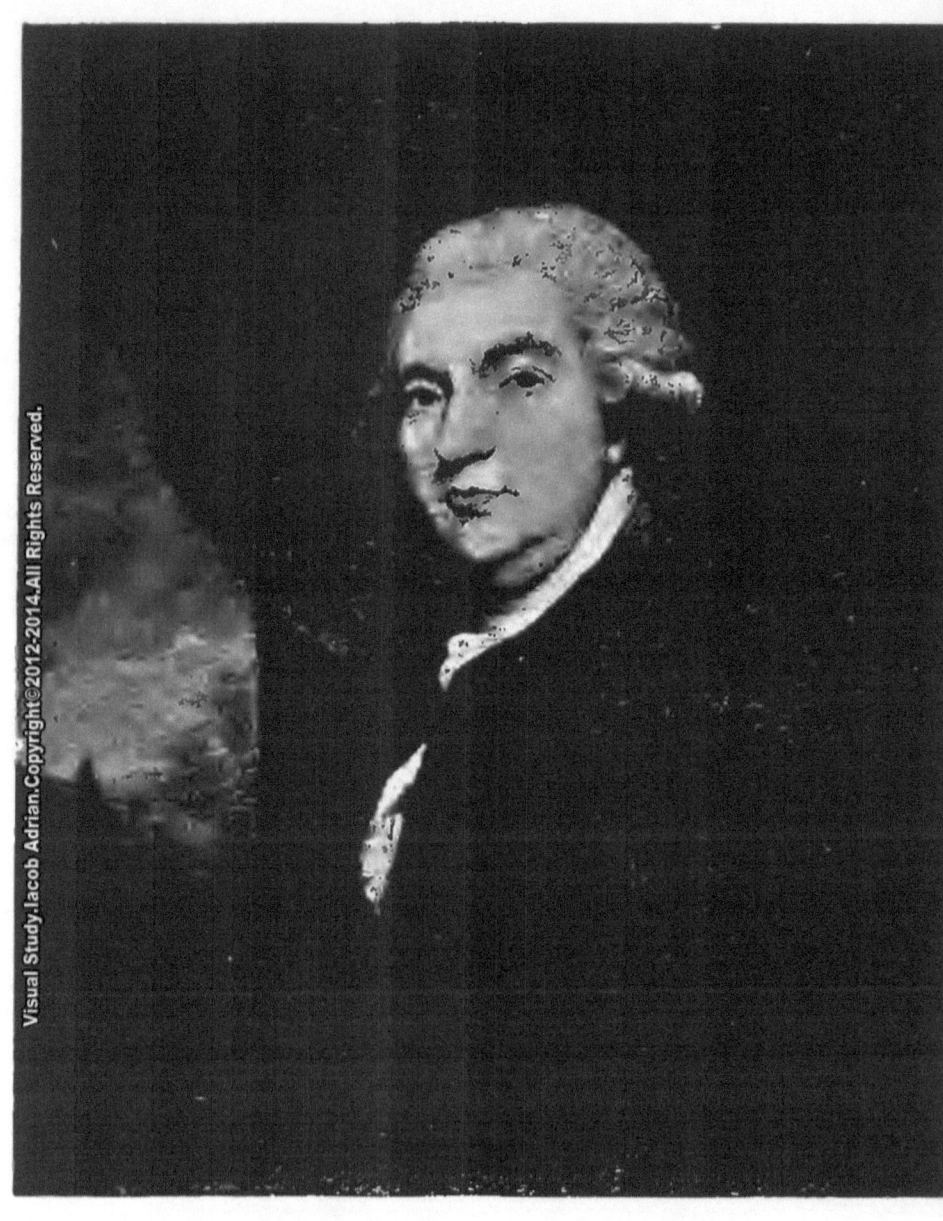

JAMES BOSWELL JAMES BOSWELL
(*National Gallery, London*) (*Galerie nationale, Londres*)
BILDNIS DES JAMES BOSWELL
(*London, Nationalgalerie*)
F. Hanfstaengl, Photo.

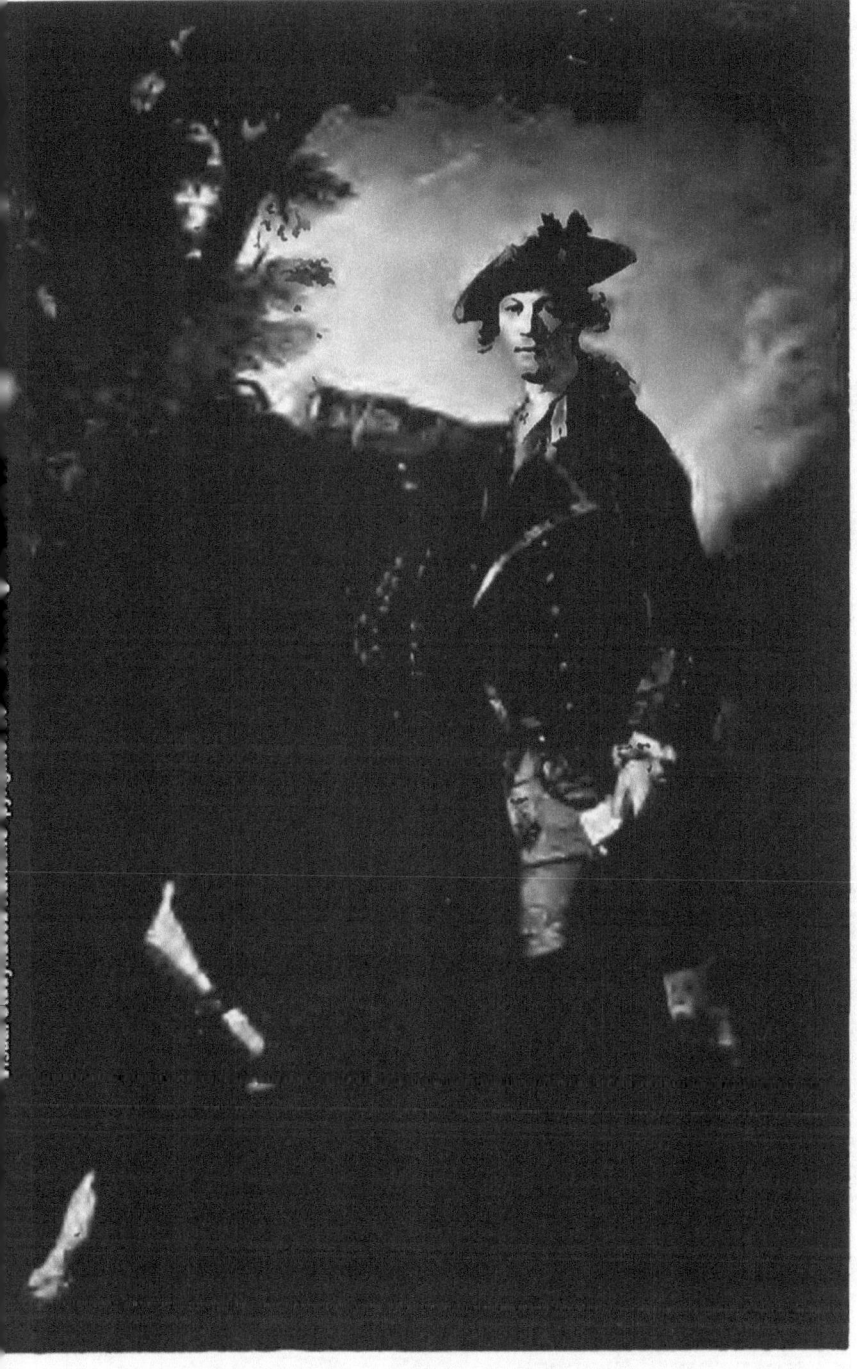

CAPTAIN ORME LE CAPITAINE ORME
(National Gallery, London) (Galerie nationale, Londres)
BILDNIS DES KAPITÄN ORME
(London, Nationalgalerie) F. Hanfstaengl, Photo.

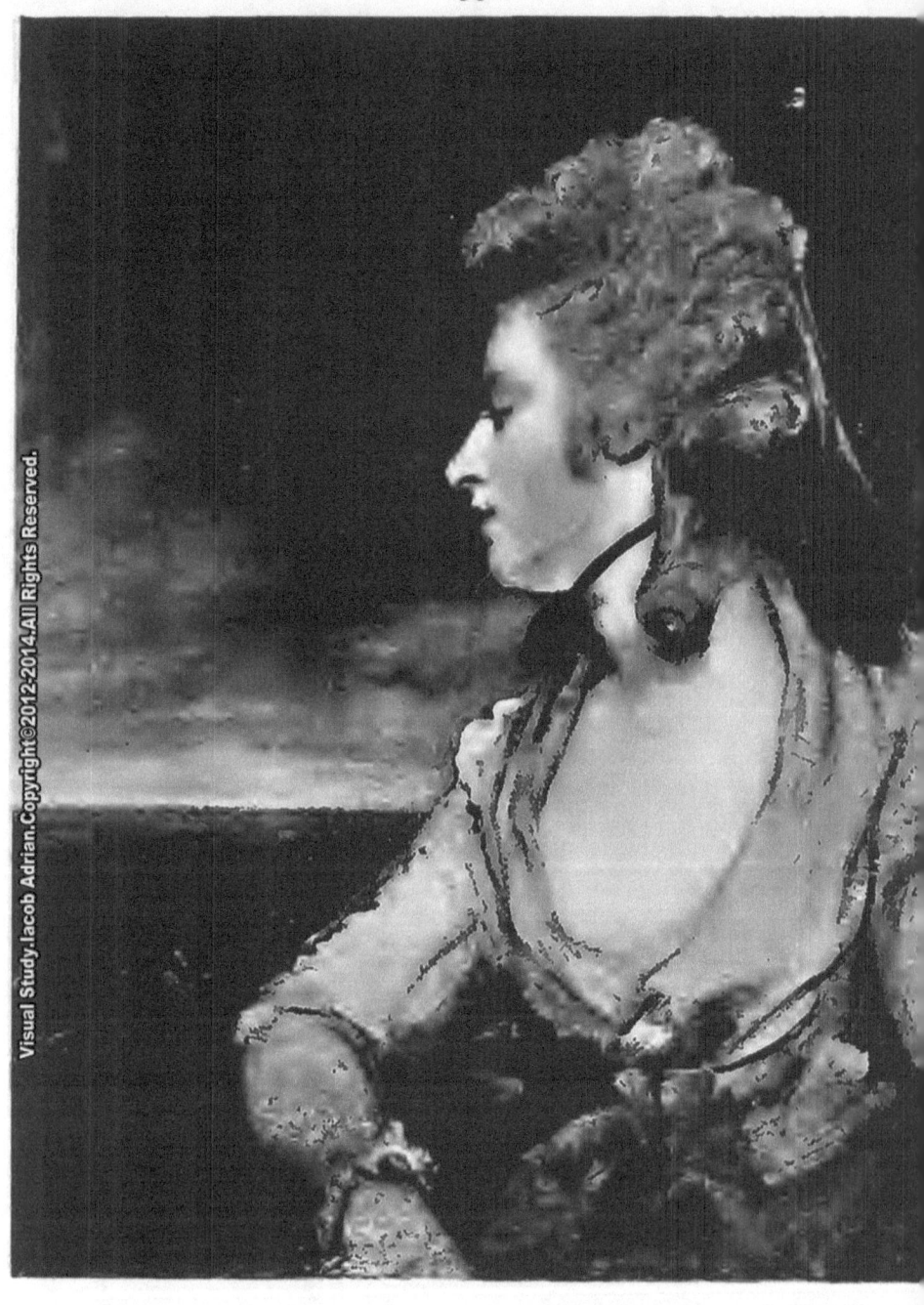

MRS. ROBINSON ("PERDITA") MME. ROBINSON ("PERDITA")
(*Wallace Collection, London*) (*Collection Wallace, Londres*)
MRS. ROBINSON
(*London, Sammlung Wallace*)
F. *Hanfstaengl, Photo.*

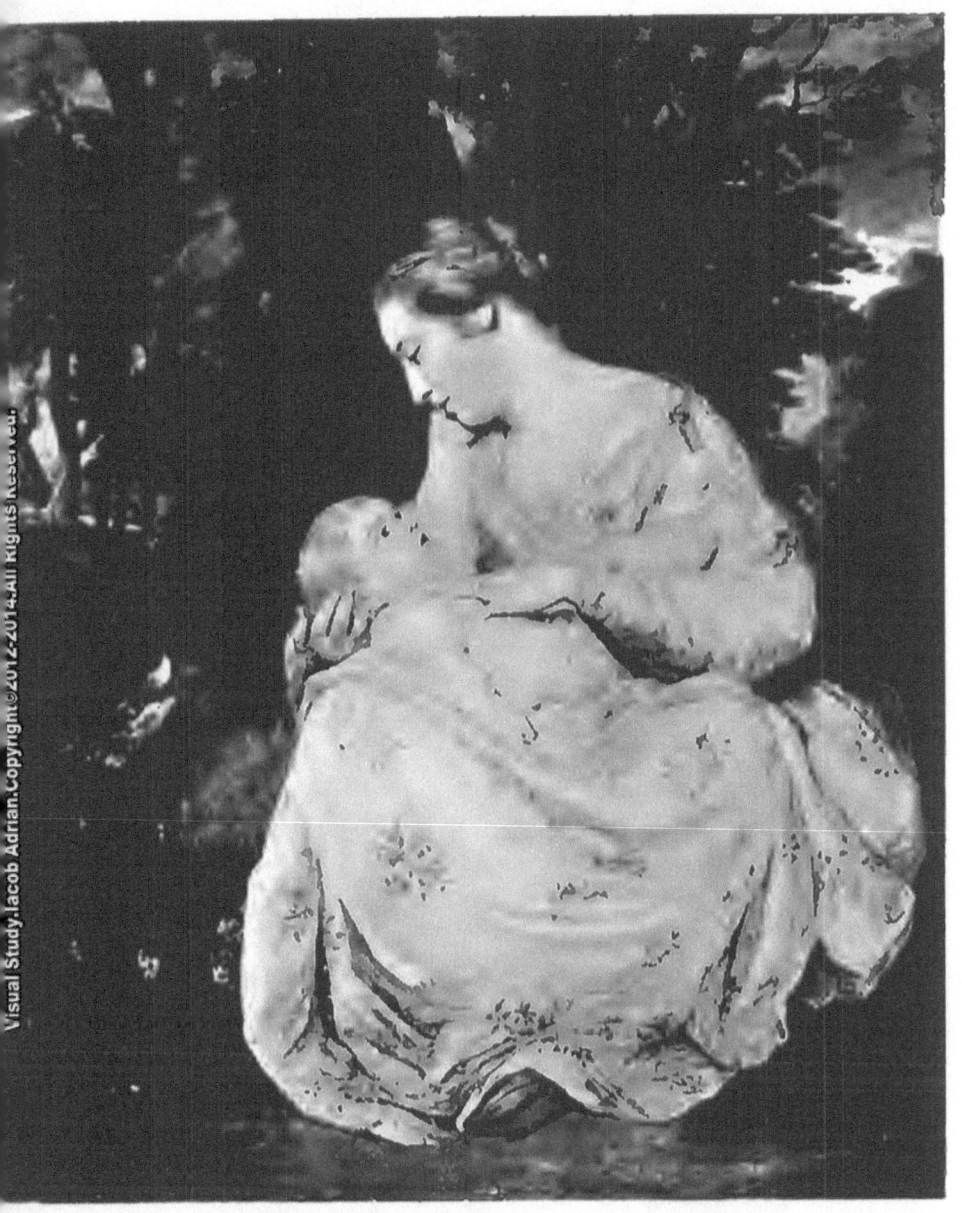

MRS. HOARE AND HER SON
(*Wallace Collection, London*)
MME. HOARE ET SON FILS
(*Collection Wallace, Londres*)
MRS. HOARE UND IHR SOHN ALS KNABE
(*London, Sammlung Wallace*)
F. Hanfstaengl, Photo.

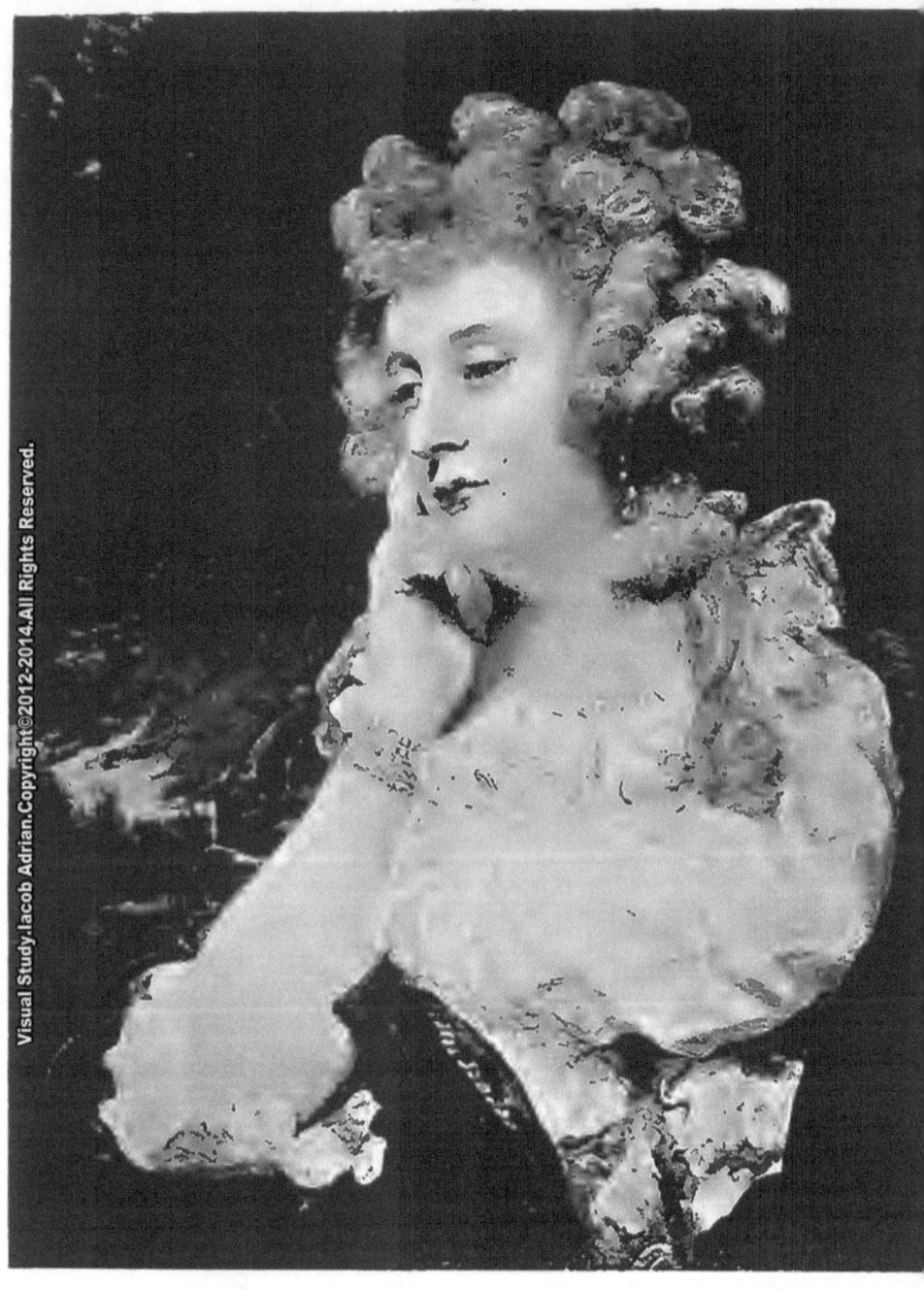

MRS. BRADDYLL
(*Wallace Collection, London*)
MME. BRADDYLL
(*Collection Wallace, Londres*)
MRS. BRADDYLL
(*London, Sammlung Wallace*)
F. Hanfstaengl, Photo.

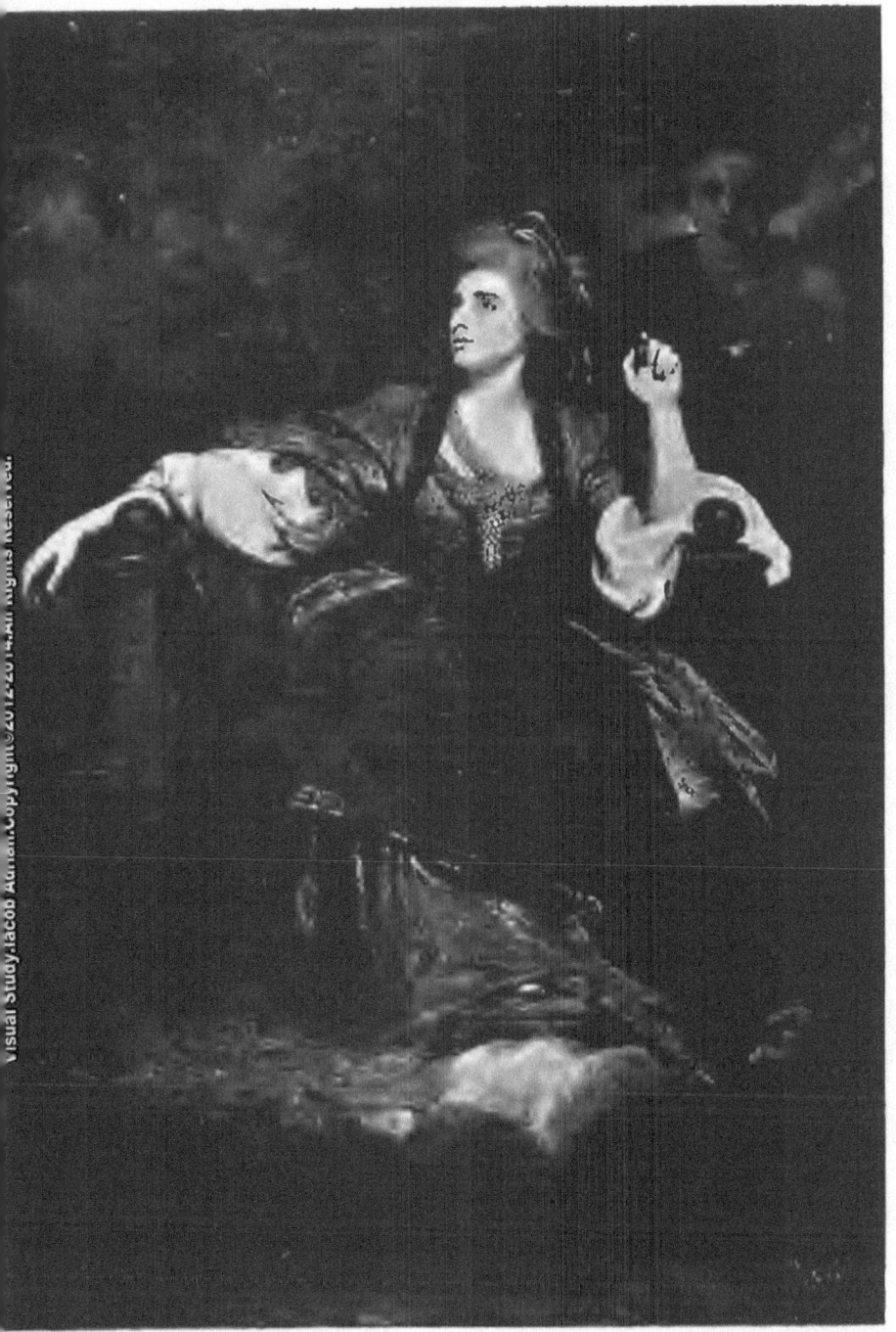

Mrs. Siddons as the Tragic Muse
(Dulwich Gallery)

Mme. Siddons comme la Muse tragique
(Galerie, Dulwich)

Mrs. Siddons als tragische Muse
(Dulwich, Galerie) F. Hanfstaengl, Photo.

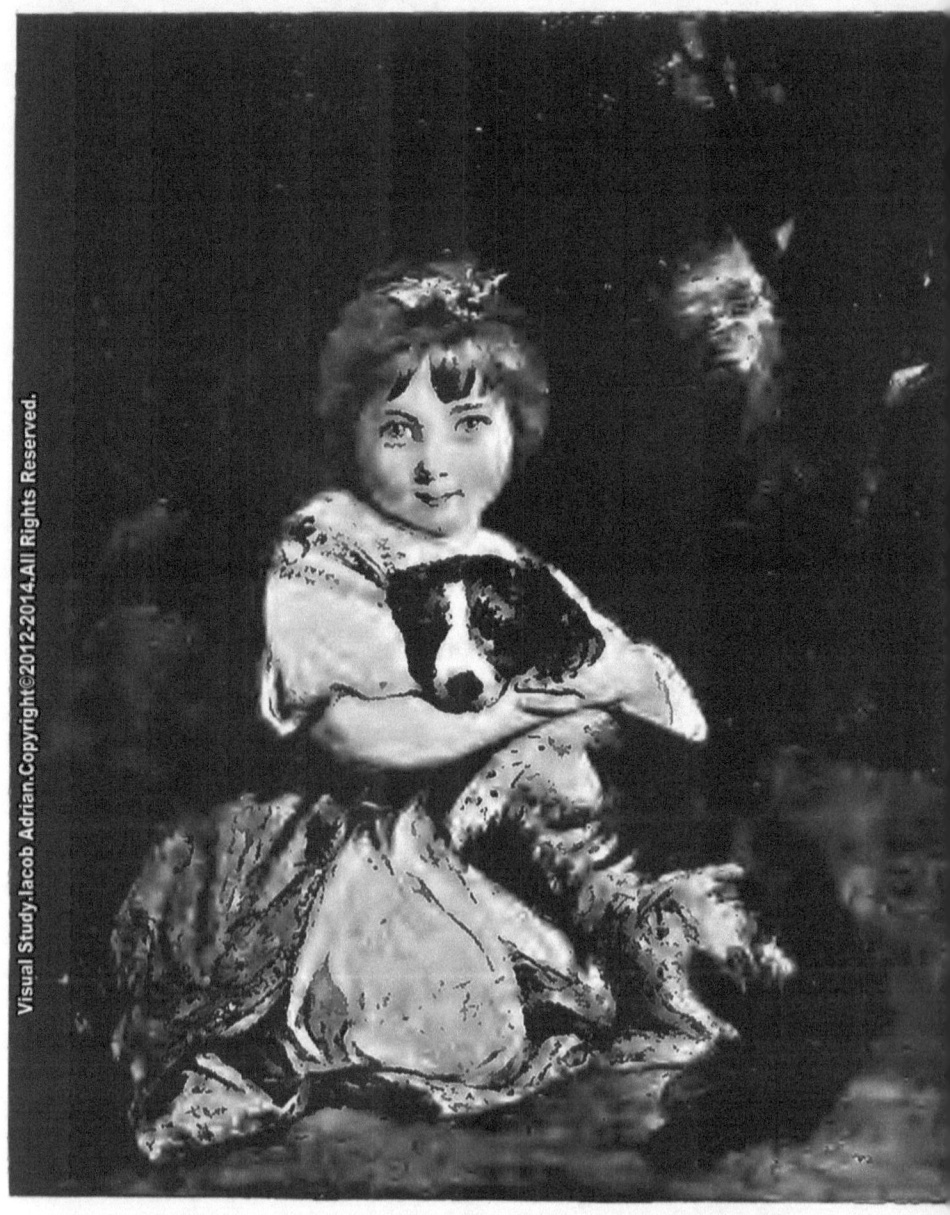

Miss Bowles
(*Wallace Collection, London*)

Mlle. Bowles
(*Collection Wallace, Londres*)

Miss Bowles
(*London, Sammlung Wallace*)
F. Hanfstaengl, Photo.

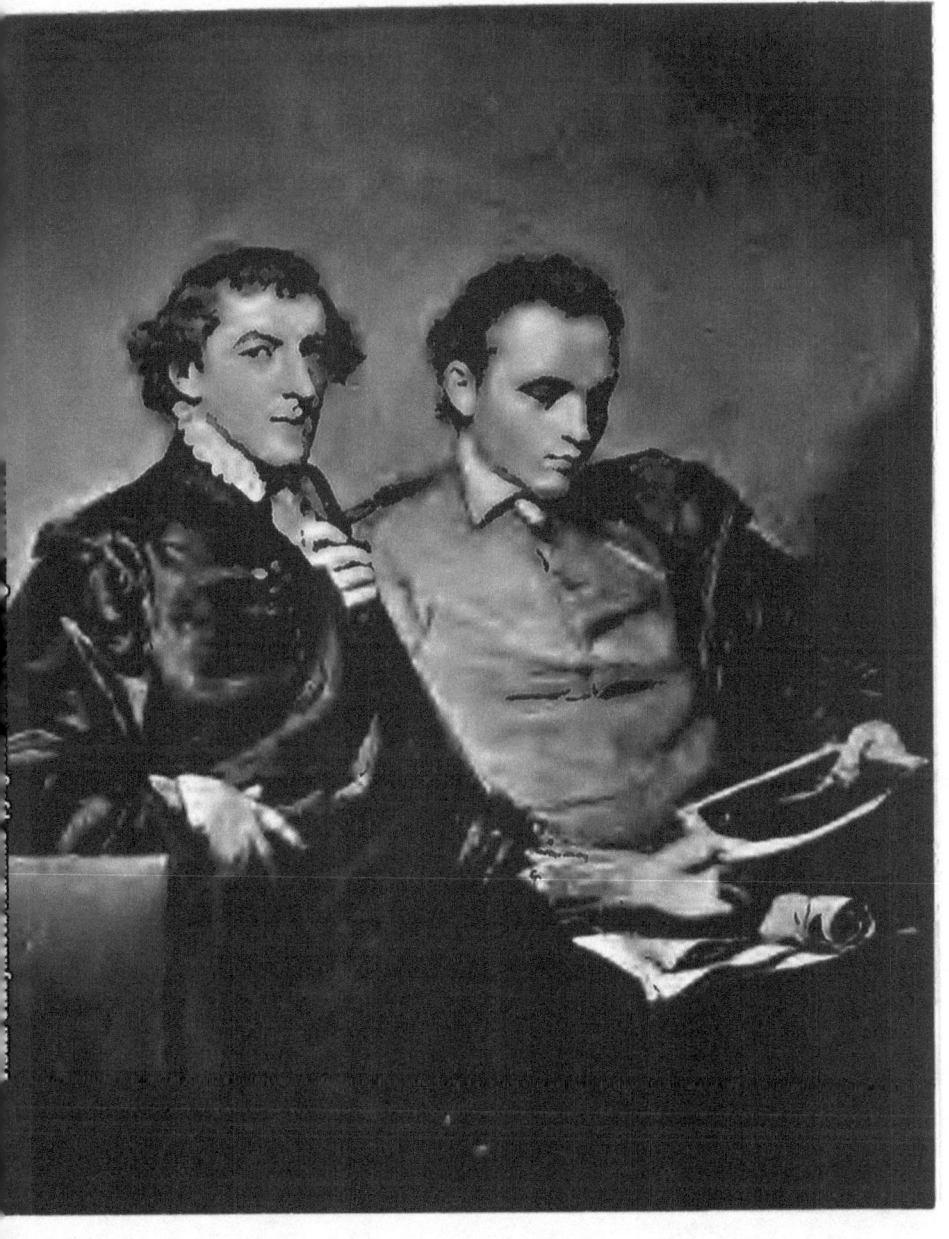

PORTRAITS OF TWO GENTLEMEN
(GEO. HUDDESFORD AND
J. C. W. BAMPFYLDE)
(*National Gallery, London*)

PORTRAITS DE DEUX GENTILHOMMES
(GEO. HUDDESFORD ET
J. C. W. BAMPFYLDE)
(*Galerie nationale, Londres*)

BILDNIS ZWEIER HERREN (GEO. HUDDESFORD UND
J. C. W. BAMPFYLDE)
(*London, Nationalgalerie*)
F. *Hanfstaengl, Photo.*

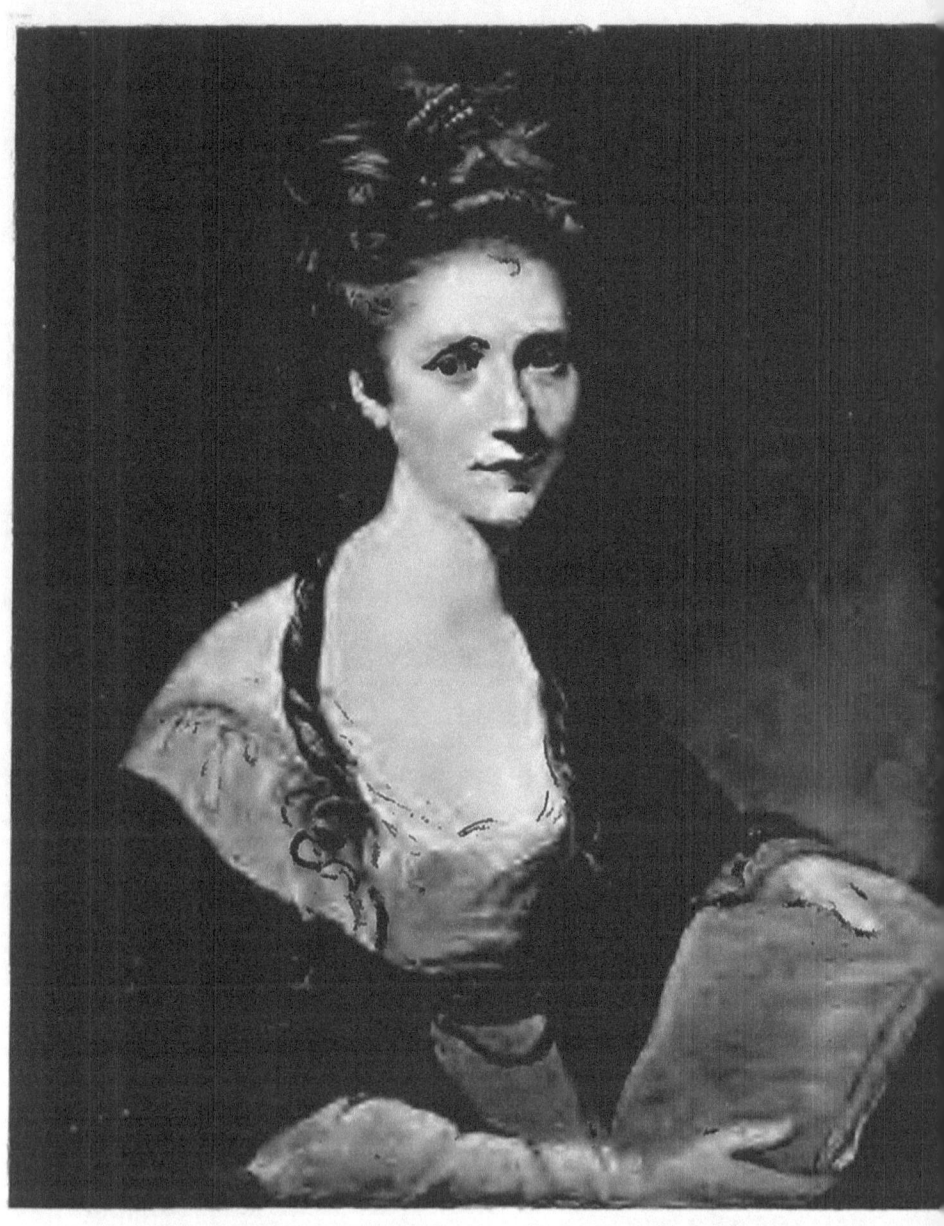

Angelica Kauffmann
(Earl Spencer, Althorp)

Angelica Kauffmann
(Comte Spencer, Althorp)

Angelica Kauffmann
(Althorp, Graf Spencer)
F. Hanfstaengl, Photo.

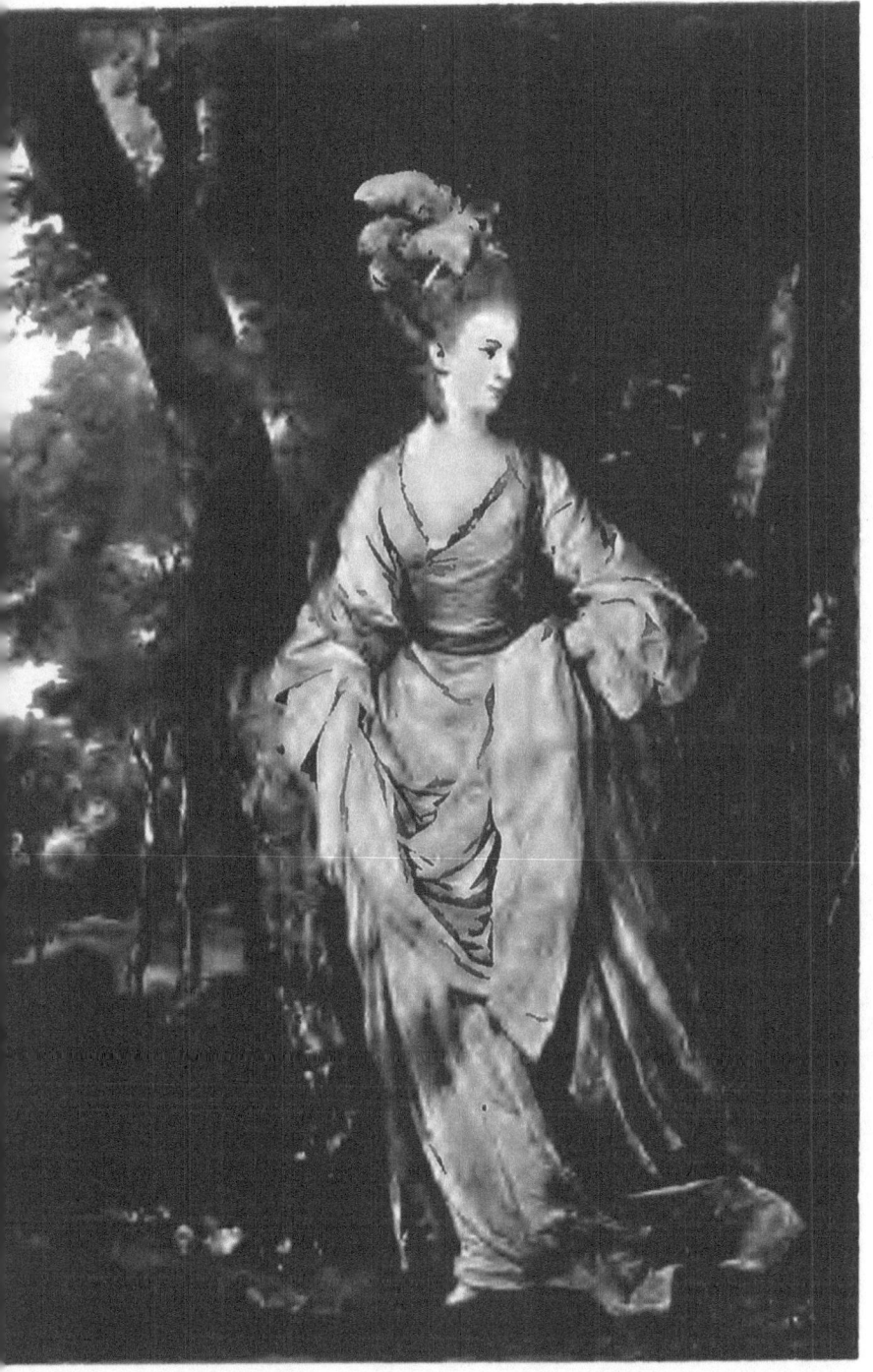

Mrs. Carnac Mme. Carnac
(Wallace Collection, London) (Collection Wallace, Londres)
Mrs. Carnac
(London, Sammlung Wallace) F. Hanfstaengl, Photo.

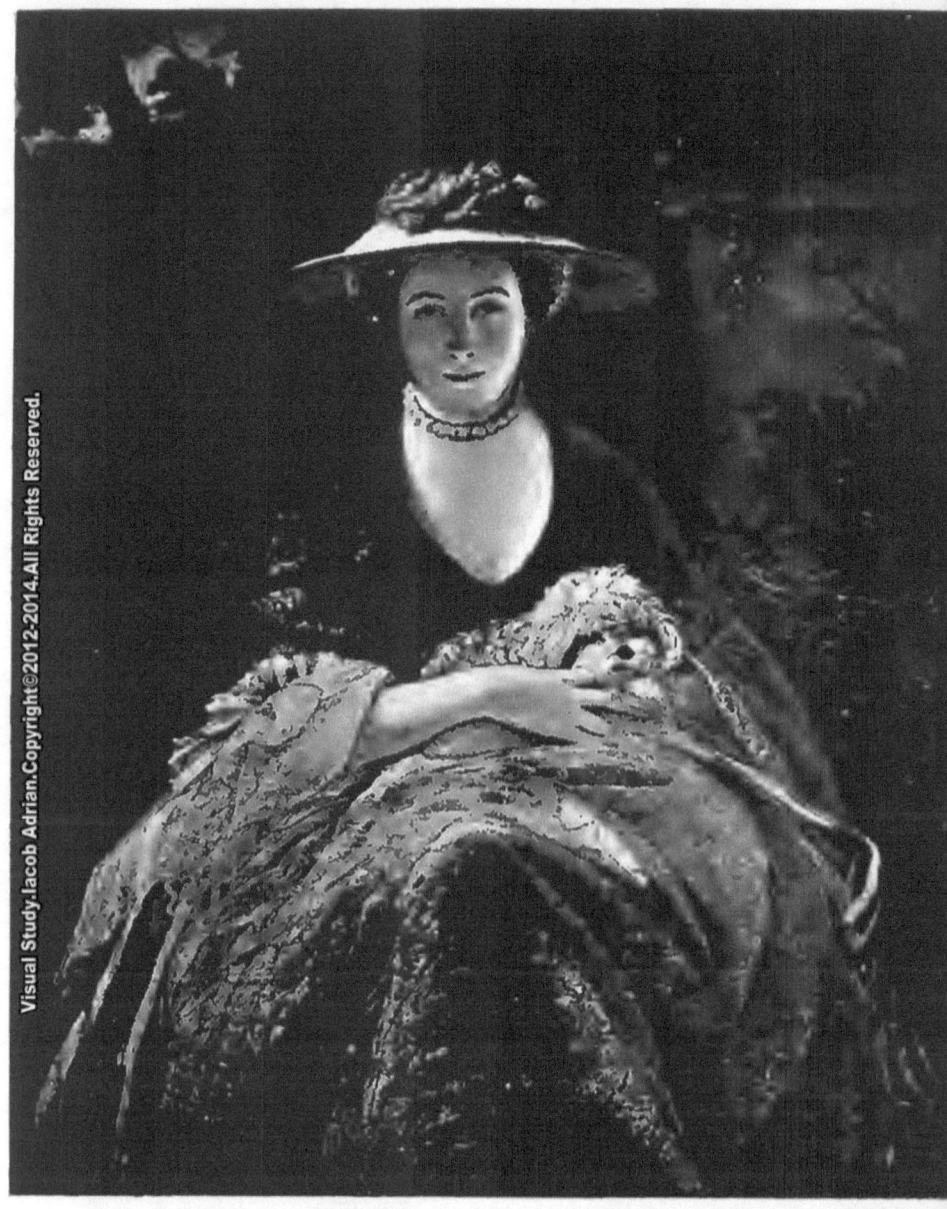

NELLY O'BRIEN
(Wallace Collection, London)

NELLY O'BRIEN
(Collection Wallace, Londres)

NELLY O'BRIEN
(London, Sammlung Wallace)
F. Hanfstaengl, Photo.

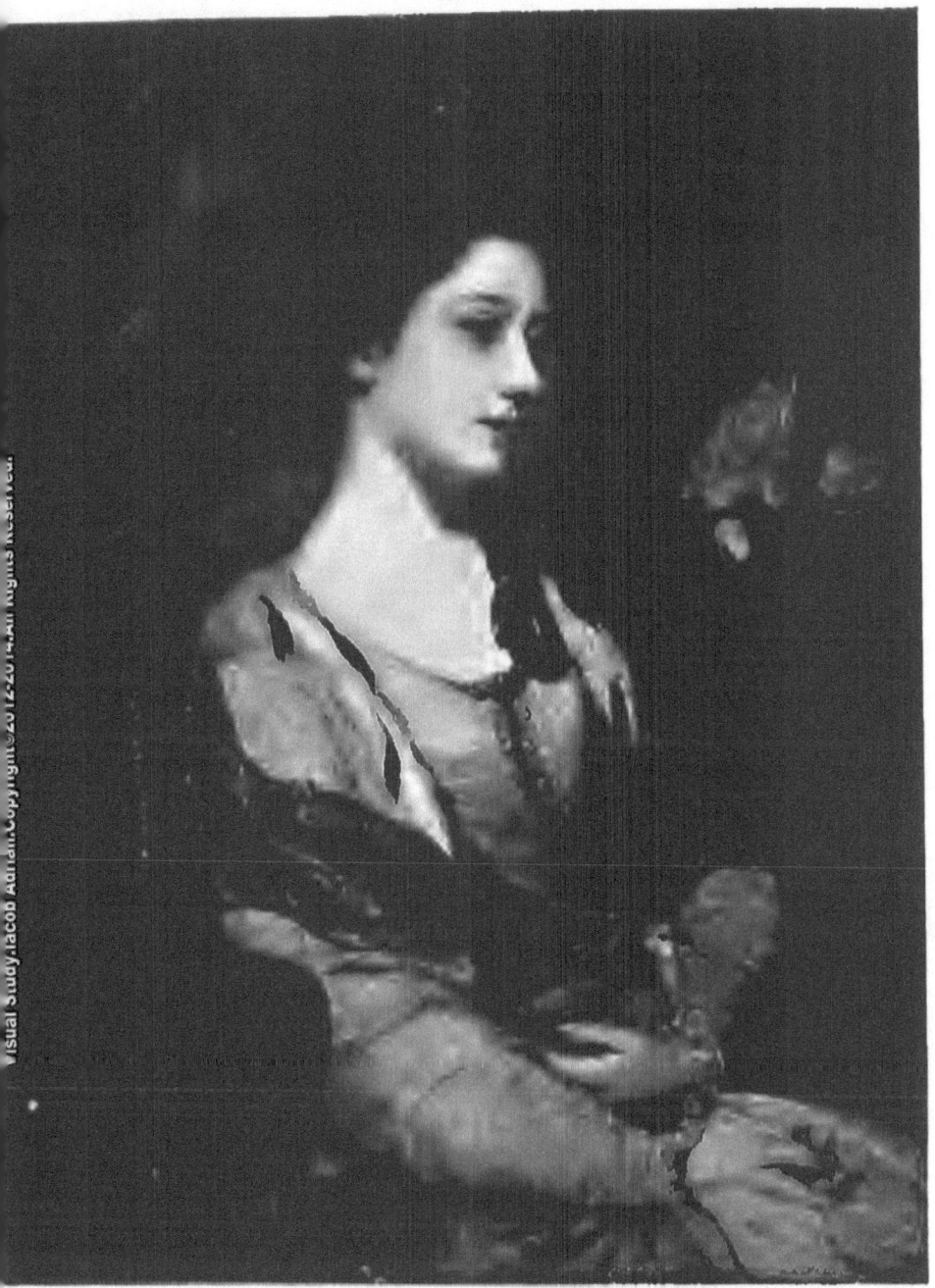

KITTY FISHER
(*The Earl of Crewe*)

KITTY FISHER
(*Graf von Crewe*)
F. Hanfstaengl, Photo.

KITTY FISHER
(*Comte de Crewe*)

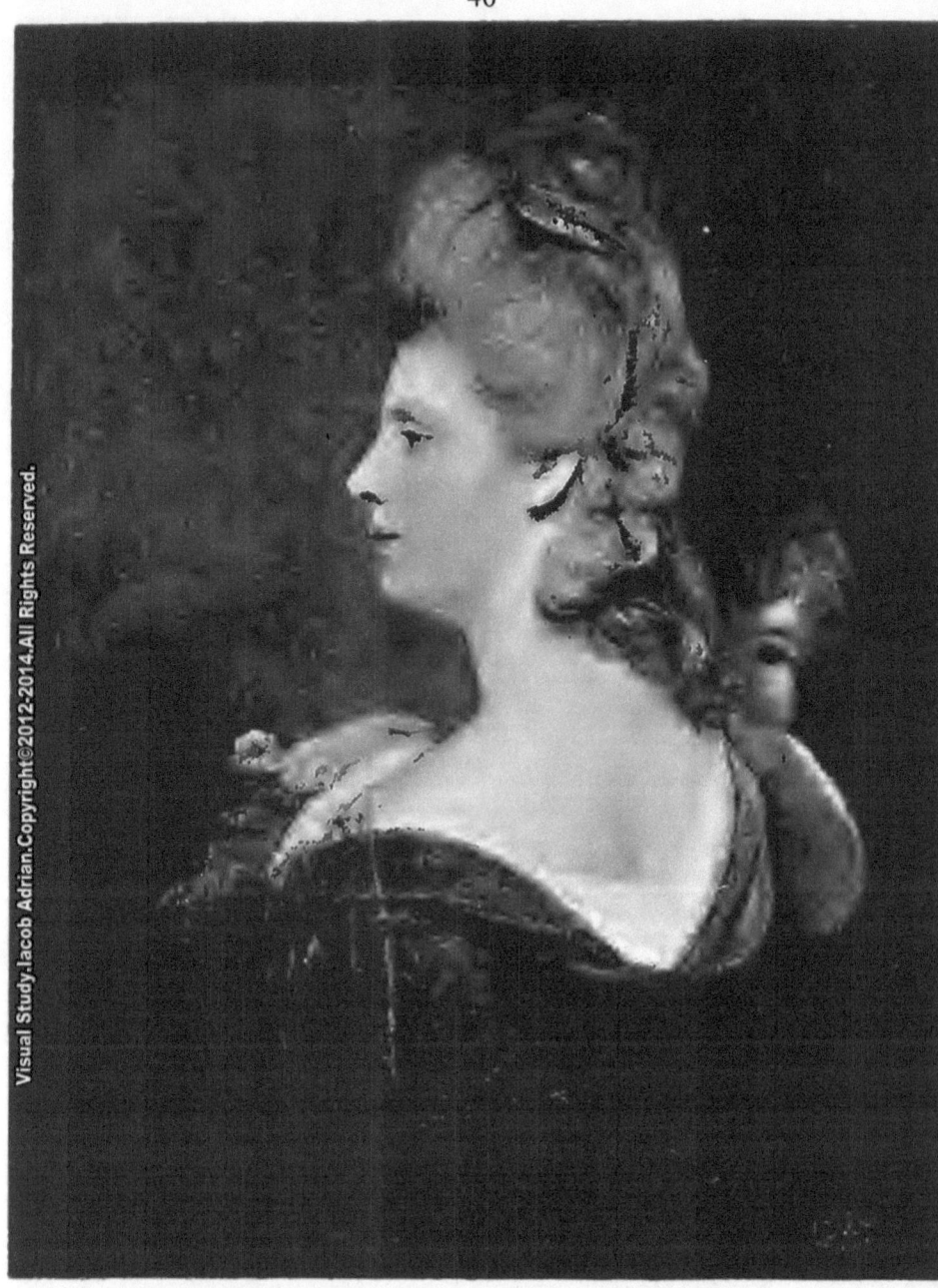

PORTRAIT OF A LADY
(MRS. MUSTERS)
(*National Gallery, London*)
PORTRAIT D'UNE DAME
(MME MUSTERS)
(*Galerie nationale, Londres*)
BILDNIS EINER DAME (MRS. MUSTERS)
(*London, Nationalgalerie*)
F. Hanfstaengl, Photo.

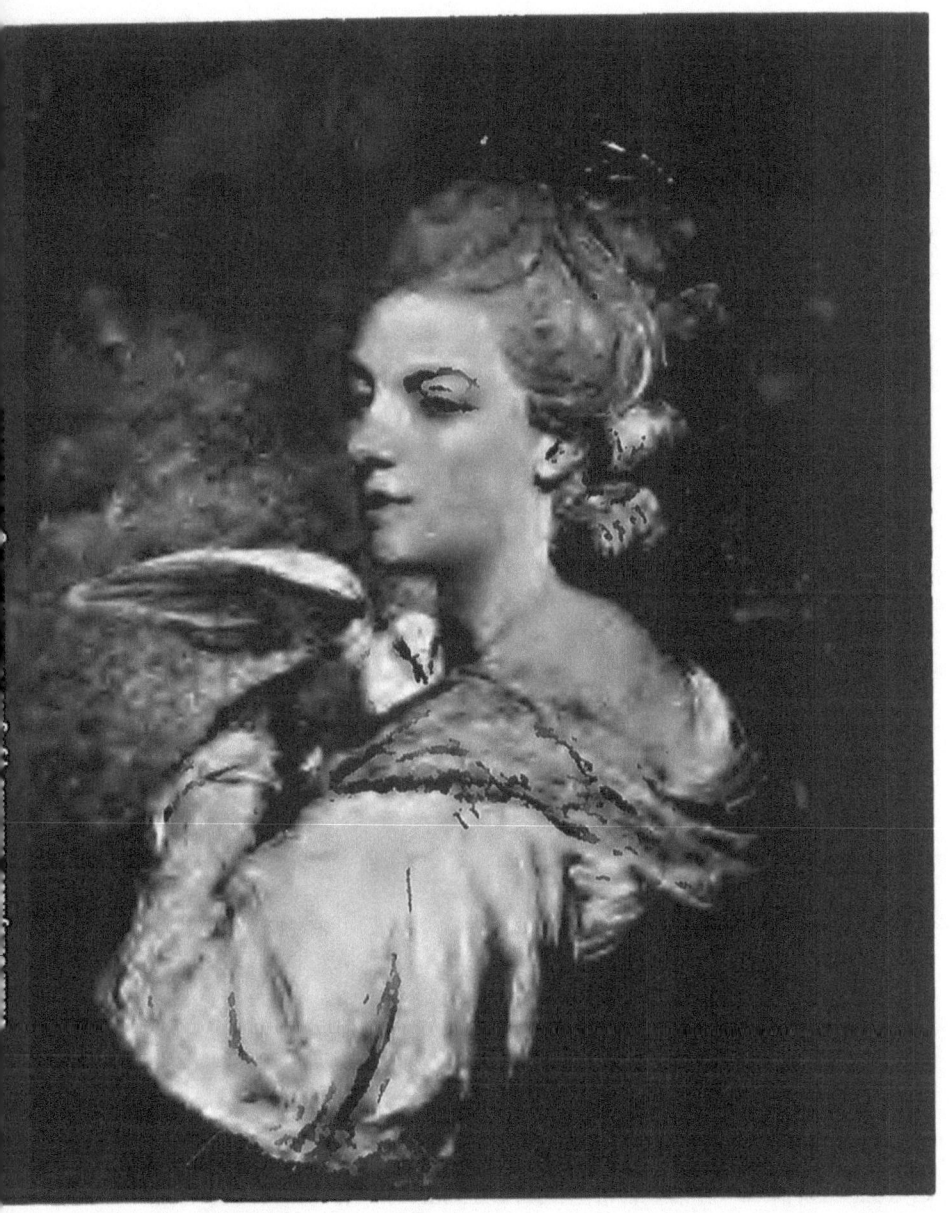

Mrs. Nesbitt
(Wallace Collection, London)

Mme Nesbitt
(Collection Wallace, Londres)

Mrs. Nesbitt
(London, Sammlung Wallace)

F. Hanfstaengl, Photo.

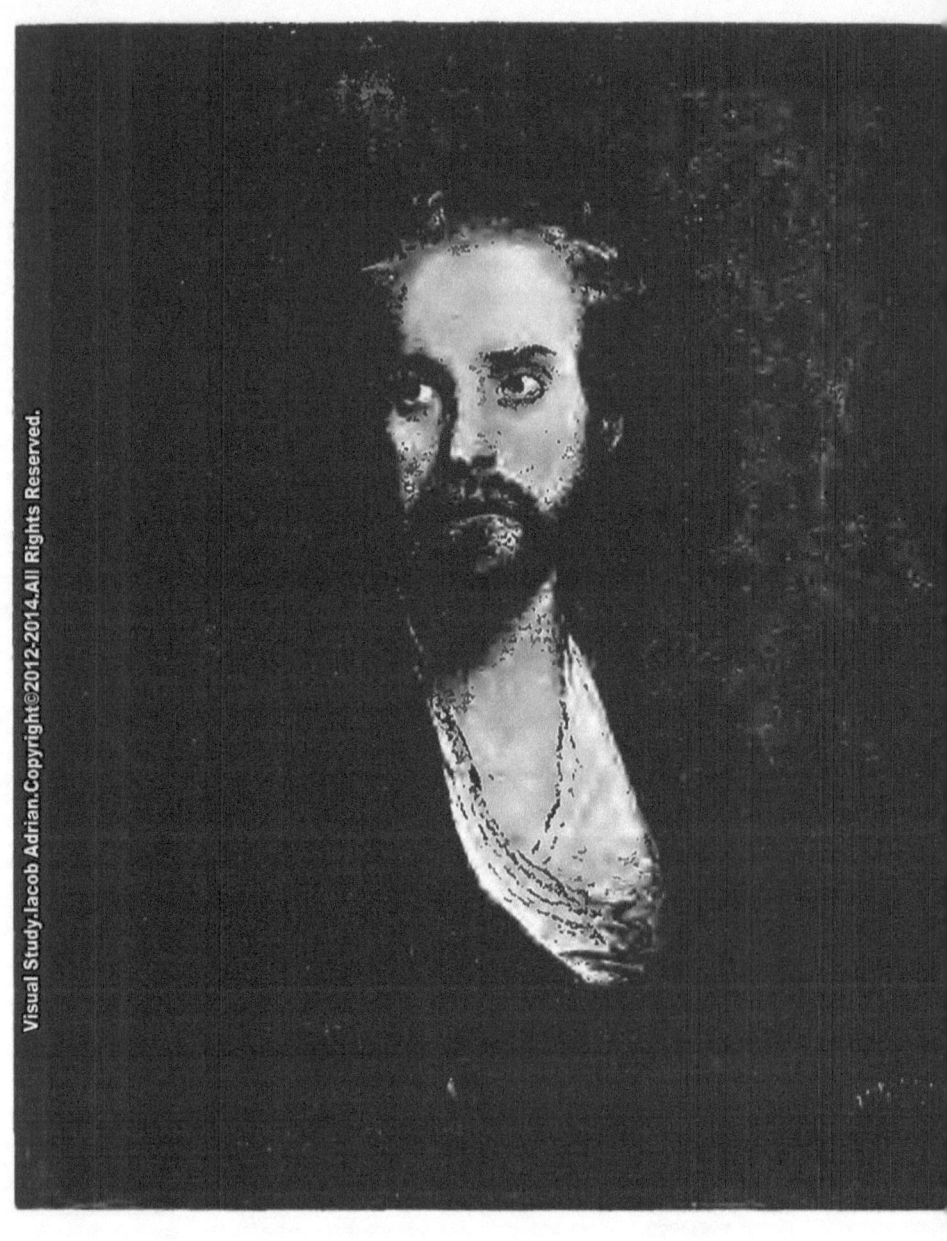

THE BANISHED LORD
(*National Gallery, London*)

LE LORD BANNI
(*Galerie nationale, Londres*)

DER VERBANNTE GRAF
(*London, Nationalgalerie*)
F. Hanfstaengl, Photo.

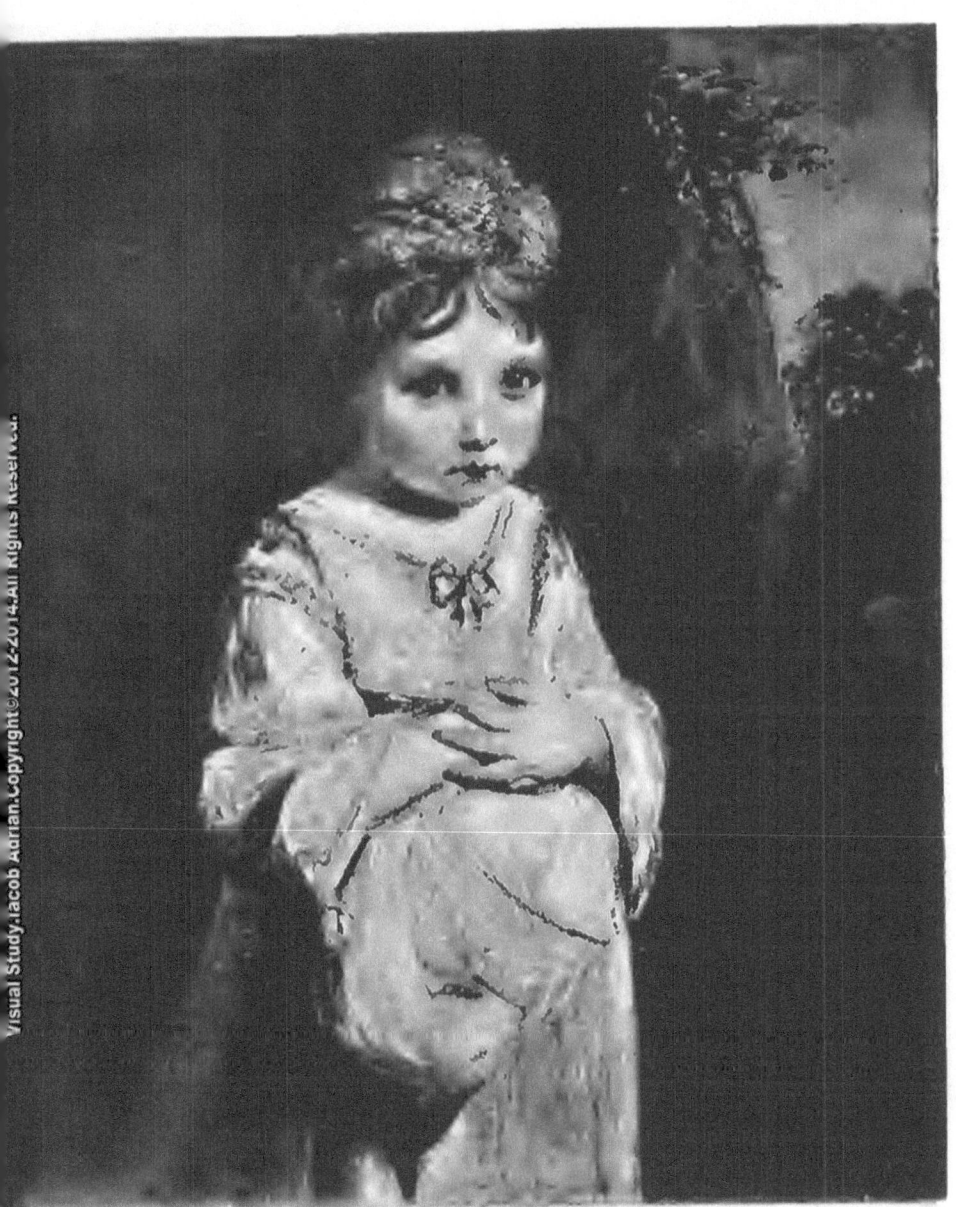

THE STRAWBERRY GIRL
(Wallace Collection, London)
LA FILLE AUX FRAISES
(Collection Wallace, Londres)
MÄDCHEN MIT ERDBEEREN
(London, Sammlung Wallace)
F. Hanfstaengl, Photo.

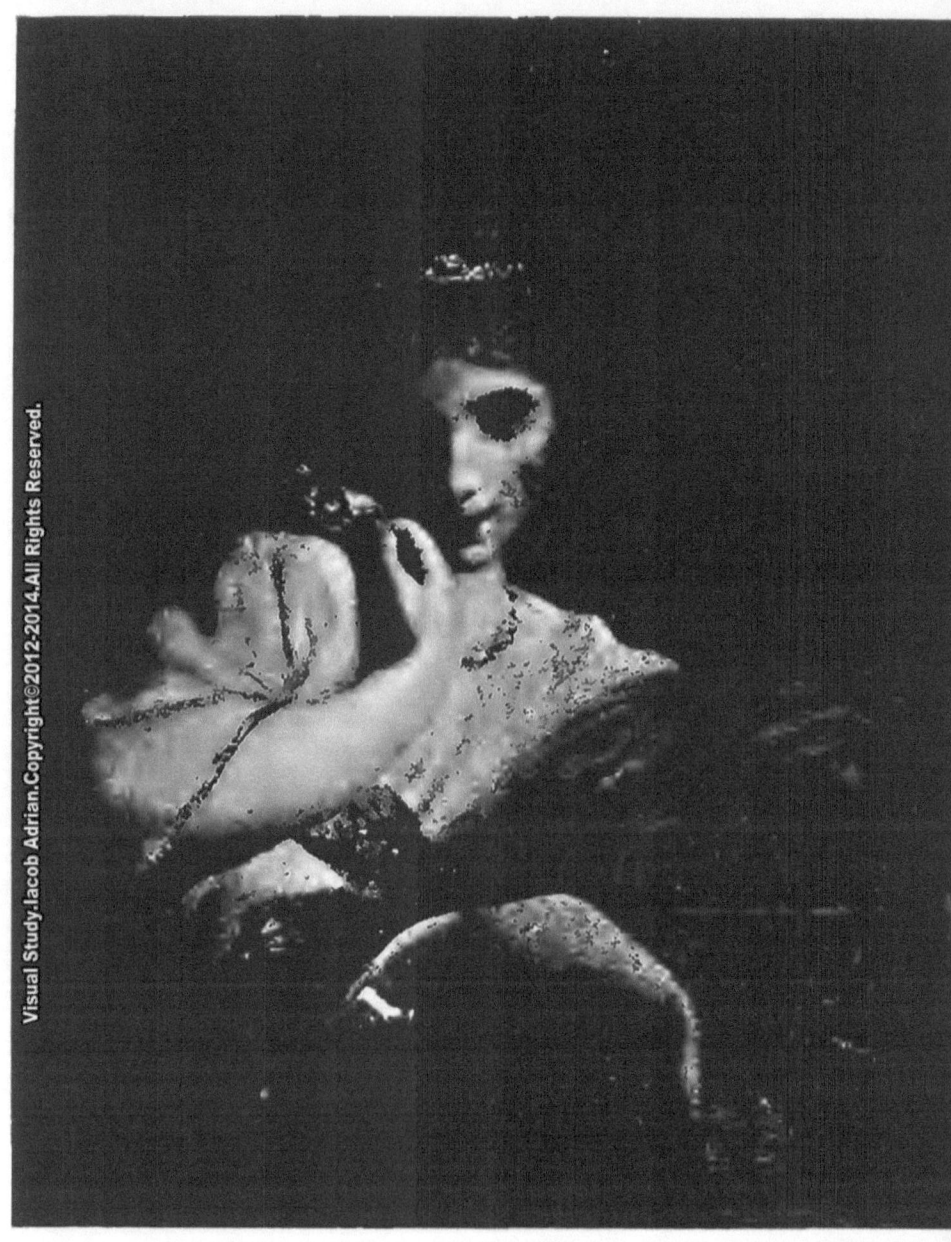

ROBINETTA
(National Gallery, London)

ROBINETTA
(Galerie nationale, Londres)

ROBINETTA
(London, Nationalgalerie)

A Mother and her Sick Child Une Mère et son Enfant malade
(Dulwich Gallery) (Galerie, Dulwich)
Eine Mutter und ihr krankes Kind
(Dulwich, Galerie) F. Hanfstaengl, Photo.

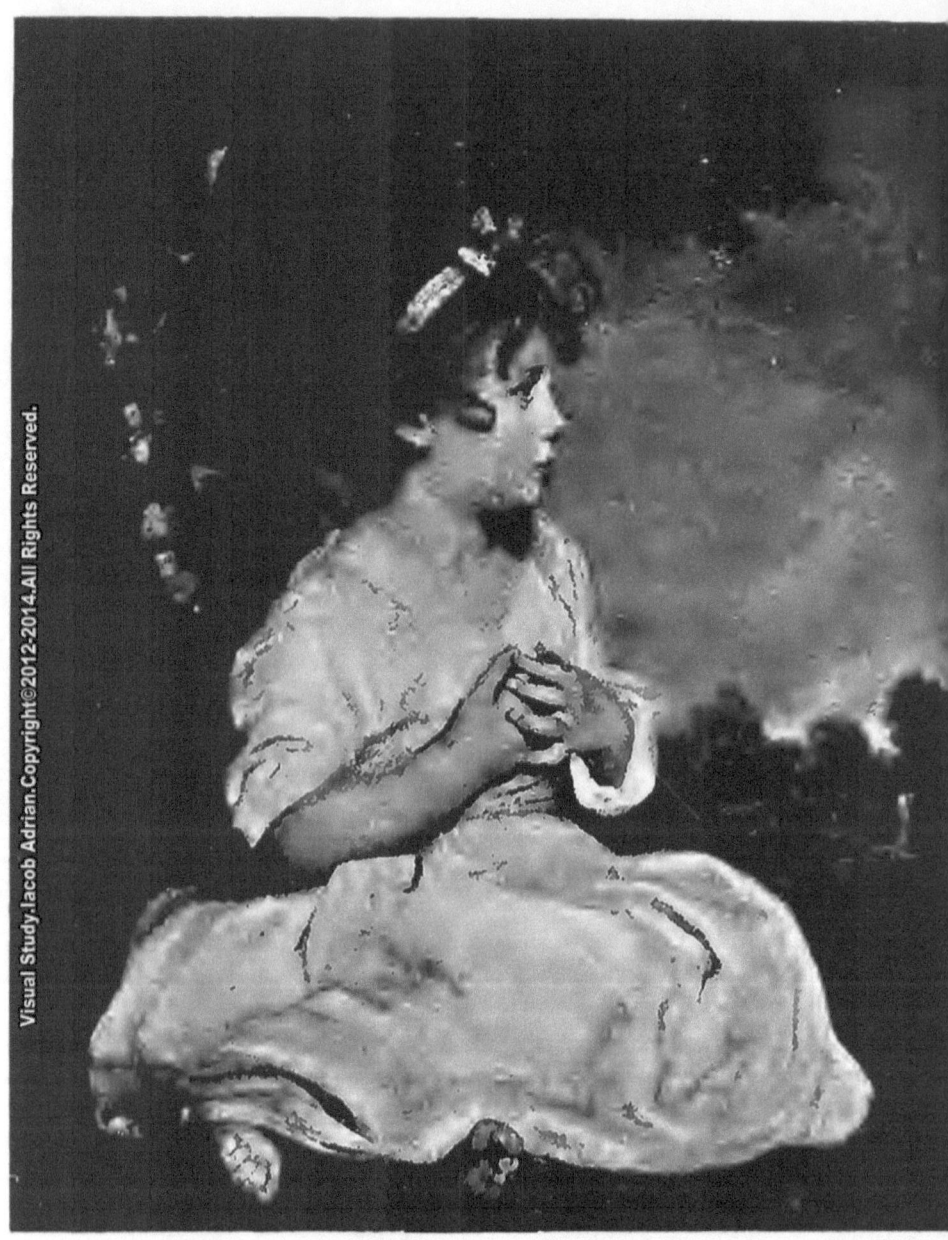

THE AGE OF INNOCENCE
(*National Gallery, London*)

L'AGE DE L'INNOCENCE
(*Galerie nationale, Londres*)

DAS ALTER DER UNSCHULD
(*London, Nationalgalerie*)

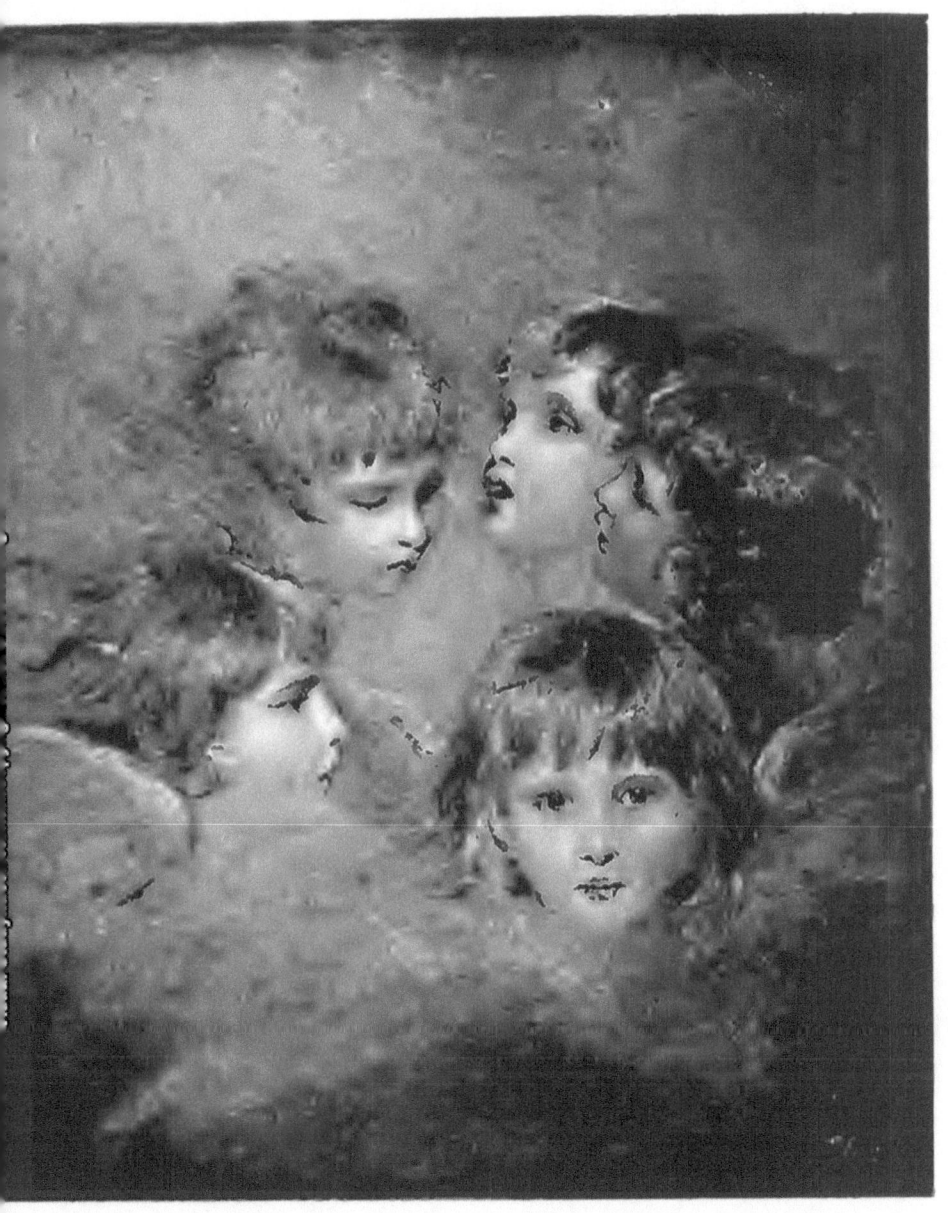

HEADS OF ANGELS
(*National Gallery, London*)

TÊTES D'ANGES
(*Galerie nationale, Londres*)

ENGELSKÖPFE
(*London, Nationalgalerie*)
F. Hanfstaengl, Photo.

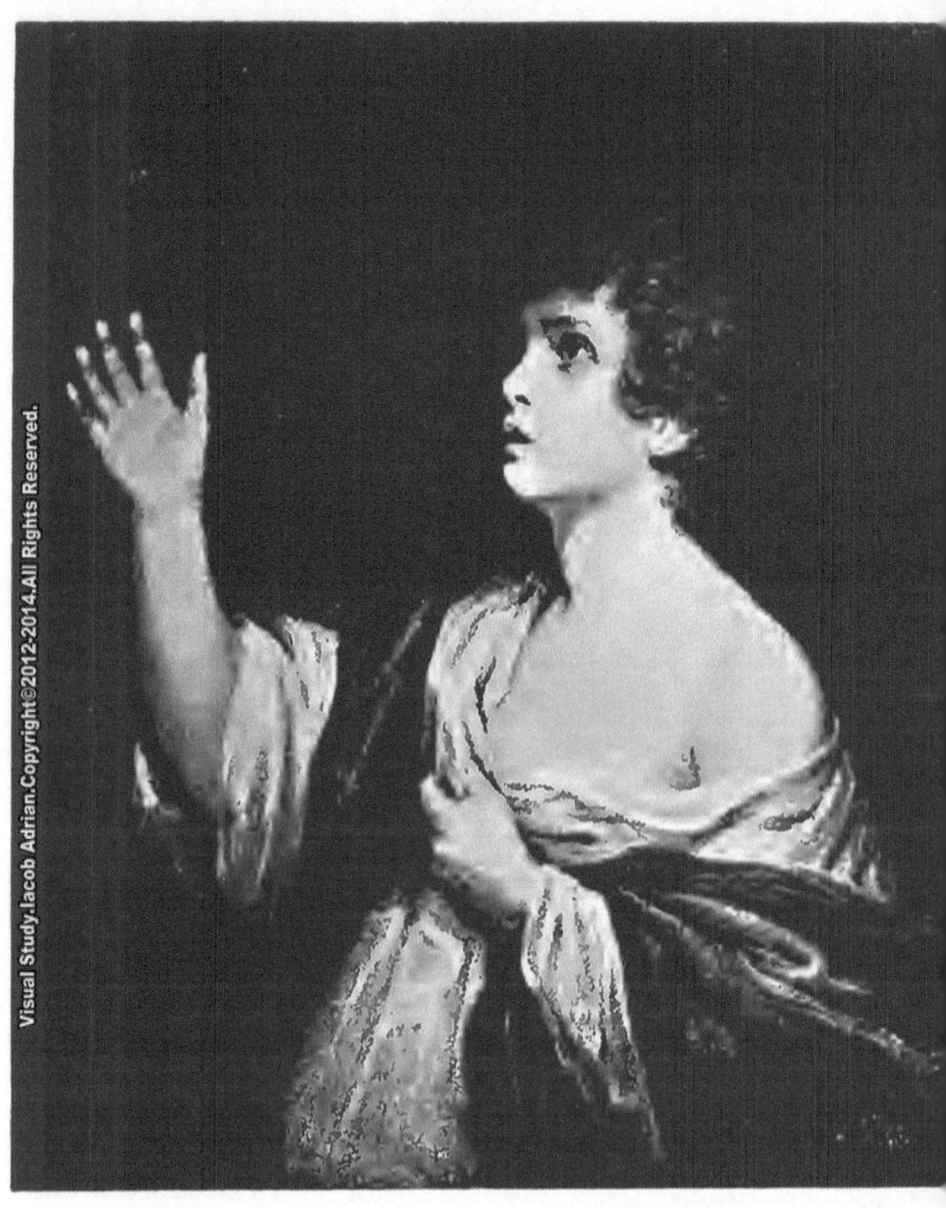

The Prophet Samuel
(*Dulwich Gallery*)

Le Prophète Samuel
(*Galerie, Dulwich*)

Der Prophet Samuel
(*Dulwich, Galerie*)
F. Hanfstaengl, Photo.

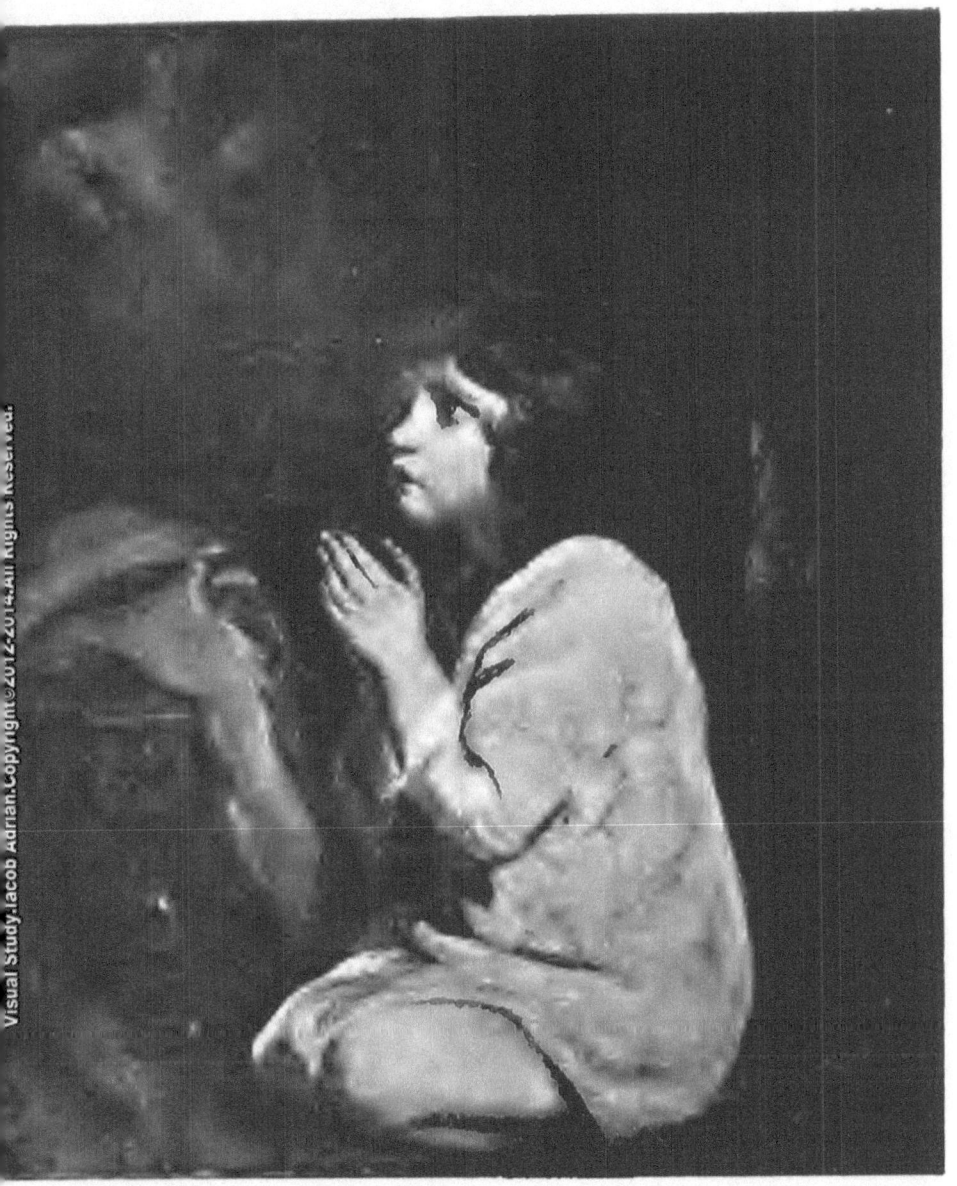

THE INFANT SAMUEL KNEELING
IN PRAYER
(*National Gallery, London*)
DER KLEINE SAMUEL.
(*London, Nationalgalerie*)
F. Hanfstaengl, Photo.

LE PETIT SAMUEL PRIANT
(*Galerie nationale, Londres*)

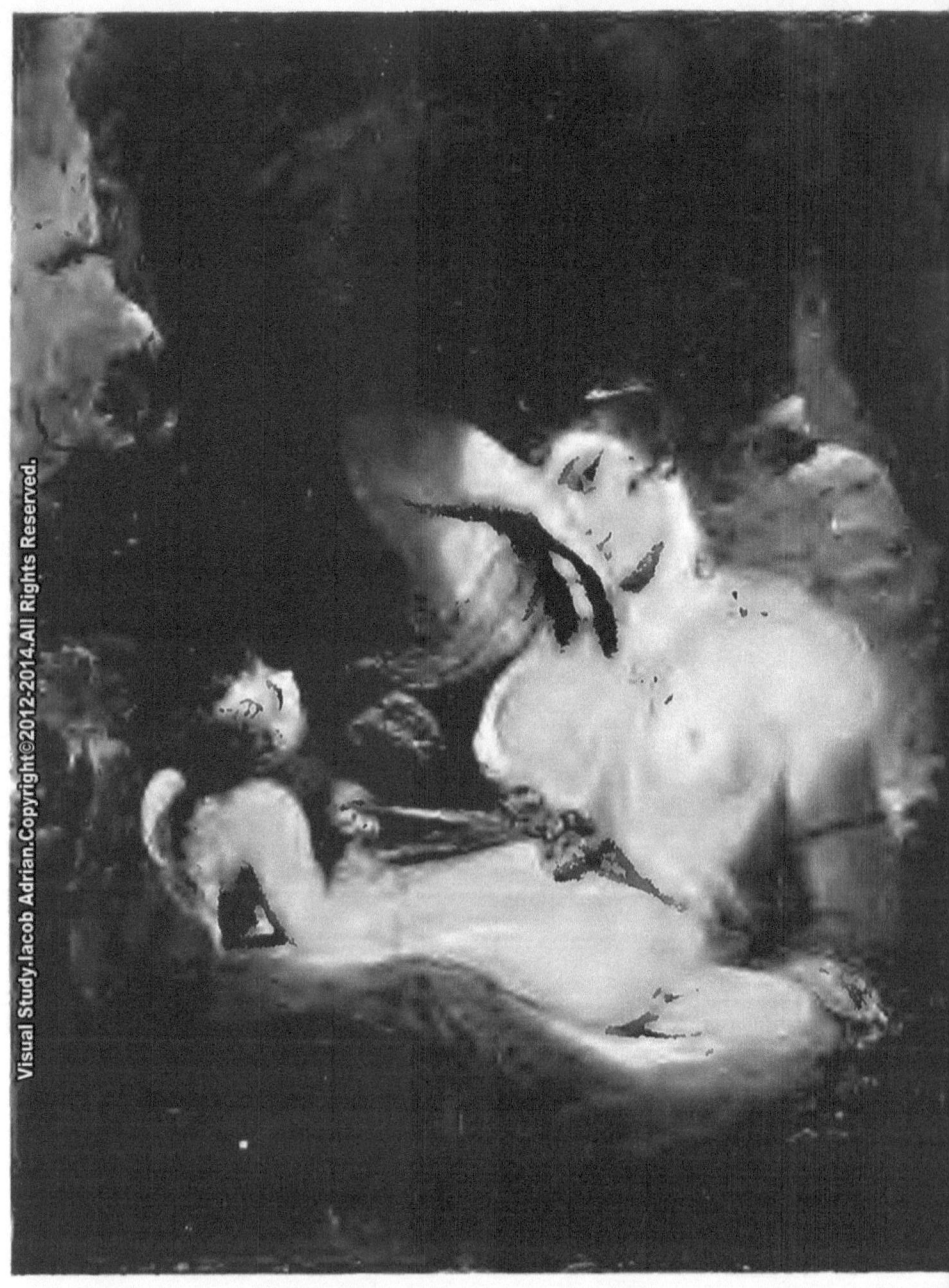

Cupid loosening the Girdle of Venus
(*The Hermitage, St. Petersburg*)
L'Amour détachant la Ceinture de Vénus
(*L'Ermitage, Saint-Pétersbourg*)
Amor löst den Gürtel der Venus
(*Petersburg, Eremitage*)
F. Hanfstaengl, Photo.

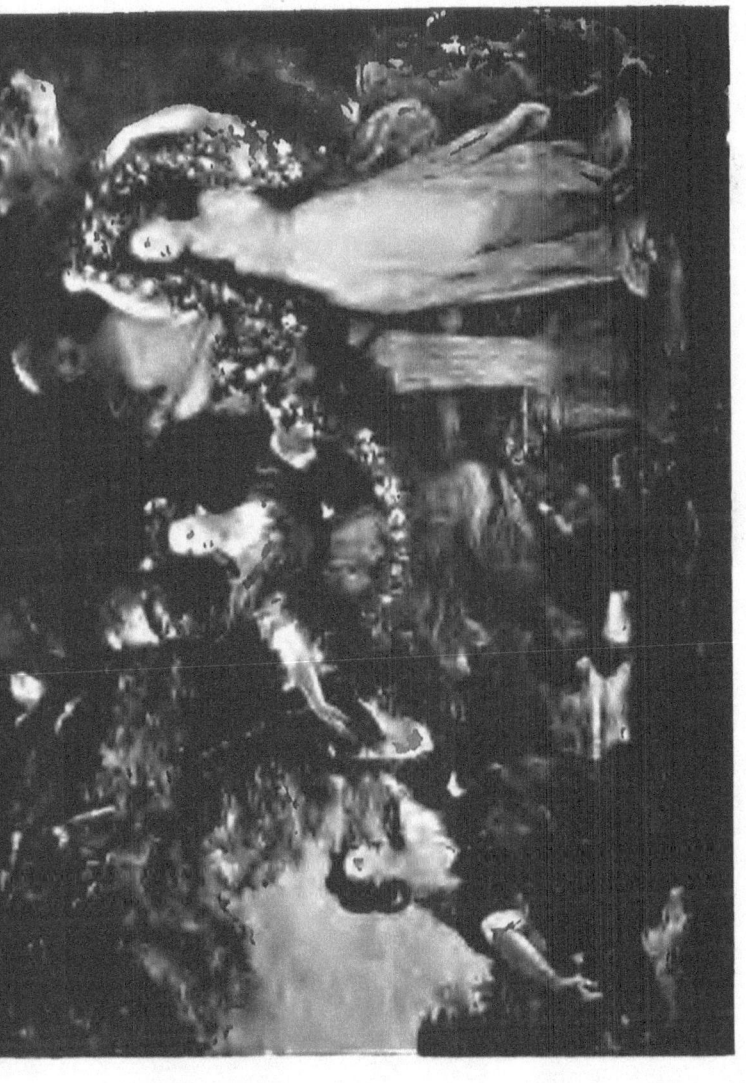

THE GRACES DECORATING A TERMINAL LES GRÂCES ORNANT UNE
FIGURE OF HYMEN FIGURE D'HYMEN
(*National Gallery, London*) (*Galerie nationale, Londres*)
DIE GRAZIEN BEKRÄNZEN EINE FIGUR DES HYMEN
(*London, Nationalgalerie*) *F. Hanfstaengl, Photo.*

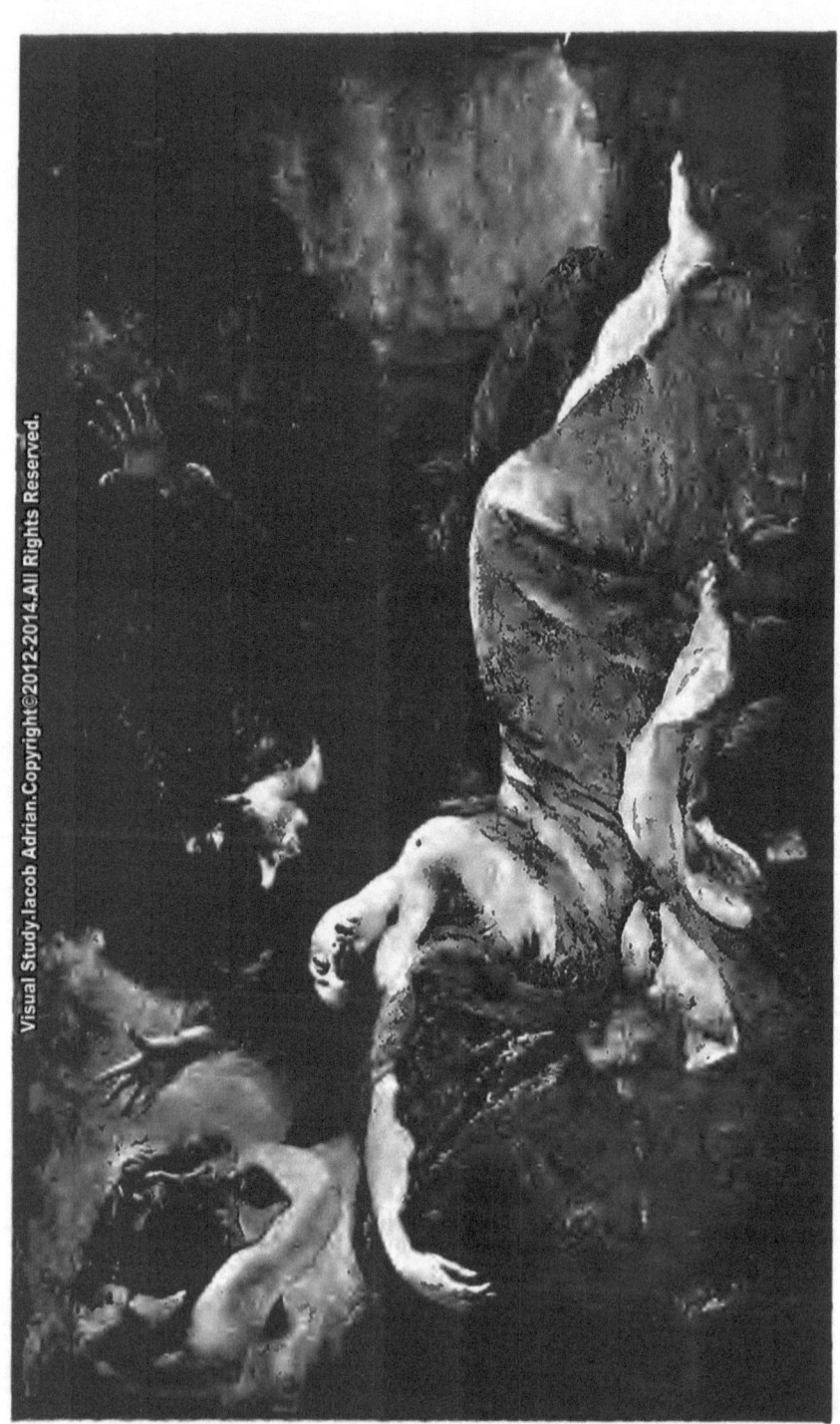

THE DEATH OF DIDO DIE STERBENDE DIDO LA MORT DE DIDO
(Buckingham Palace, London) (London, Buckinghampalast) (Palais Buckingham, Lonores)

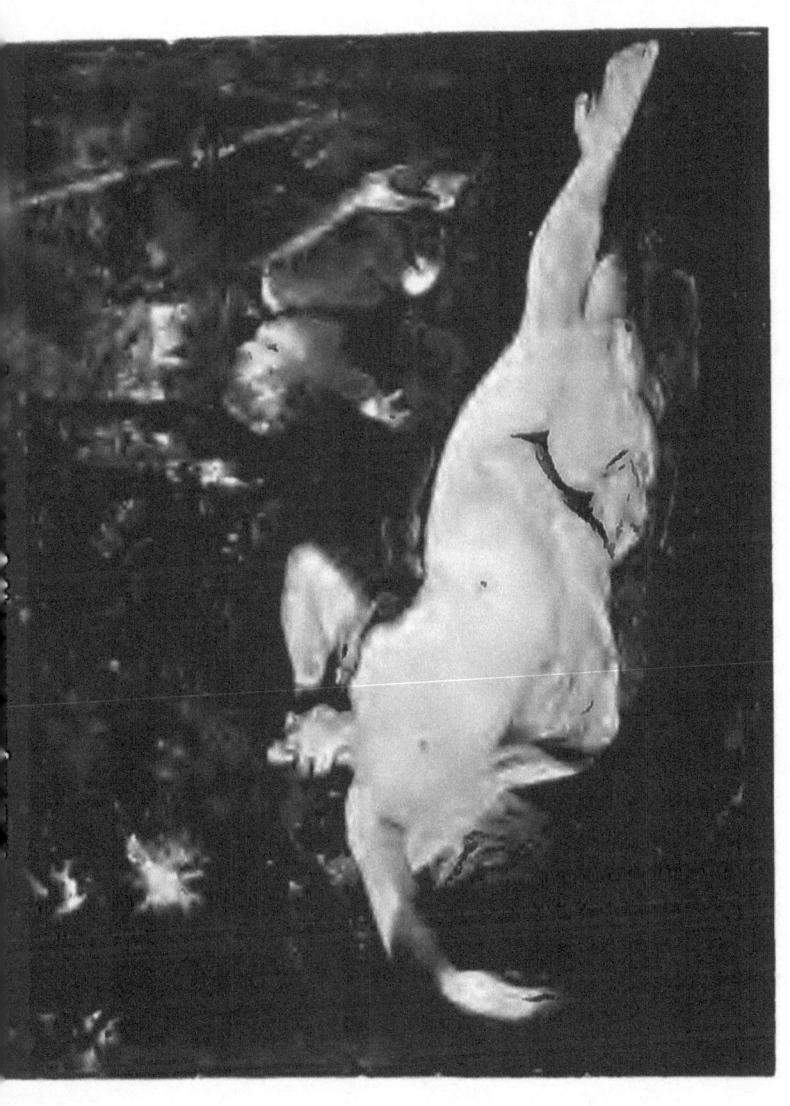

Cimon and Iphigenia
(Buckingham Palace, London)

Cimon et Iphigénie
(Palais Buckingham, Londres)

Cymon und Iphigenia
(London, Buckinghampalast) F. Hanfstaengl, Photo.

Bibliographic sources :

The masterpieces of Reynolds, 1723-1792 (1909)

Author: Reynolds, Joshua, Sir, 1723-1792

Publisher: London, Gowans & Gray

This documentary study use,
combined in various proportions,
elements from the following categories,
forms and subsets :
- fair use
- documentary
- documentary photography
- feature
- journalism
- arts journalism
- visual journalism
- photojournalism
- celebrity photography
in order to :
- employ material as the object of cultural critique ,
- quote to illustrate an argument or point ,
- use material in historical sequence,
providing independent opinion,
using photos, press articles, advertisements,
opinions of fans etc. ...

Copyright©2012-2014 Iacob Adrian
All Rights Reserved.

www.ingramcontent.com/pod-product-compliance
Lightning Source LLC
Chambersburg PA
CBHW032342200526
45163CB00018BA/2072